PHOTOGRAPHY: COMPLETE GUIDE TO TAKING

Image: Creative Commons

Stunning, Beautiful Digital Pictures

CONTENTS

INTRODUCTION

This book has been written because so many people buy digital cameras and never get further than using automatic settings. It's a real shame and although cameras are calibrated to take acceptable images using this feature, the scope of real photography goes a long way further than that.

The guide would make the perfect companion to that digital camera purchase so that those who receive the camera get the most out of it. Similarly, those who have simply just started to get interested in digital cameras can gain from this book because it's not written in a complex way that people can't understand. It's written by someone who was sitting exactly where you are now, but who learned to appreciate the intricacies of digital cameras and now shoots wonderful photographs because of letting the camera work to its maximum. Weaned on the old fashioned cameras, the writer of this guide had a lot of problems getting to grips with transferring old photographic values into new habits on a DSLR camera but once that was understood, it made the whole process of taking photographs much more interesting. The results became better and there was no turning back.

It's merely a question of getting your head around all the strange settings and it really isn't as frightening as it seems. This guide will help those who are hopelessly lost in understanding digital photography to produce stunningly beautiful digital images without too much effort at all. Every chapter is filled to brimming with information that will help the budding photographer become a very good photographer indeed, learning what the different settings on the camera mean and how to use them to advantage. This is vital if you want to produce more than the accidental image that came out well. Doing this regularly means that you are able to predict the quality of the finished image because you learned how to plan for it.

Follow through the explanations and you really will be able to produce pictures that astound your friends, but that most of all enthuse you in the art of photography. It is a very individual thing and what looks great to one photographer counts because it is the eye of the photographer and the ability to compose a picture gets coupled with an understanding of what the camera can do.

Your camera could earn you money. There are websites that offer photographers a real opportunity to get their names known online. There are also hobby websites for those who are more modest about their successes. However, once you understand the intricacies of using your digital camera, you will be proud to share your achievements.

Digital photography opens up doors to people who have perhaps never really taken the art of photography seriously. If you look back on the past to the old Brownie point and click cameras, people didn't expect to get wonderful results. They were happy with images that simply caught the moment, and even if the figures that appeared on the images were off center and sometimes the heads were chopped off, they were merely a fun distraction for the family or friends. Nowadays with DSLR cameras readily available to most people, you really can take the hobby seriously and be astounded at the results that you get because the camera has the capability to produce wonderful results once you know what all the knobs do and learn all about composition and presenting your images in the very best way possible.

Have you ever thought of hanging your photos as artwork? A photograph is just that – it's a piece of art which is as individual as the person who took the photograph and this is the way you need to start looking at your digital camera experience. Once you do, you will never look back and you will impress yourself with the images that you are able to produce, with patience, planning, the right light and the perfect moment presenting itself. That's what photography is all about and this book is written to help you to learn how to take photographs to be very proud of using your digital camera and knowing its capabilities.

If you know someone who has recently acquired a digital camera or are buying one for someone who has never used one before, this book is a good investment as a companion to that gift, as it will help them to enjoy the scope that is open to them as a new photographer. It will also help those who have digital cameras and are a little nervous of their use, opening up ideas that will help that photographer become more than a "point and click" photographer and helping them into the realm of professionalism that takes their approach to photography a step in the right direction.

CHAPTER 1

WHAT IS DSLR PHOTOGRAPHY?

DSLR is a short form for digital single lens reflex camera. With this camera, you see everything the way the lens sees it and can change the lens if you want. Additionally, the camera has a near zero lag time, which is the best especially if you are doing action photography. To help you have a full grasp of what a Digital SLR or DSLR is, it is perhaps important that you first understand some of the mechanics of this camera.

In a nutshell, light passes through the lens then strikes a mirror, which in turn reflects the light up to a focusing screen. Afterwards, light passes through this focusing screen then enters a block the pentaprism (this is a block of glass). The pentaprism then reflects the image enabling you to see it in the viewfinder.

So when you take any photo, the mirror then flips up allowing the shutter to open in order to expose the digital sensor to light. In simple terms, what you see is what you get. You can use the viewfinder to compose the image and even adjust the focus.

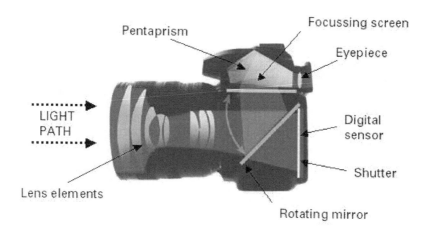

So, does that mean what you see in the viewfinder is 100% representative of what you will get in the final image? The answer is a simple no. In many instances, your DSLR will probably only give you about 95% of the image that the sensor will capture; this is often referred to as coverage. As a beginner, you might hardly notice any difference in the photo unless you are really keen at it.

As you start your DSLR photography journey, you should also realize that Digital SLR viewfinders will vary in brightness. In a nutshell, bright viewfinders will make it easy for you to use manual focus given that you are able to see the subject more clearly.

DSLRs are far much superior compared to conventional point and shoot cameras in terms of quality and response thanks to the larger imaging sensors that DSLRs have. As a rule of thumb in photography, the bigger the sensor, the better the photograph. DSLRs have amazing capture speeds rated in fps (frames per second); you will realize that most DSLRs can capture photos are least 4fps, which literally means that you can capture action right as it happens without missing a shot or blurring your photos due to the speed of the object being photographed.

DSLR cameras are preferred by photographers because of their vast features. With a DSLR camera, you can control the style and focus of a scene and customize the white balance. It is also possible to make customizations on the menu according to your preference. The real appeal of a DSLR camera is the clear, high quality photographs it produces and its ease of use when taking multiple shots.

As a beginner, there is an excitement that comes with owning a DSLR. You may feel like running outside and taking terabytes of photos. However, there is a lot you have to learn about DSLR photography in order to take full advantage of the technology. Here is an overview of the features to give you a good head start on your shooting experience.

CHAPTER 2

FINDING YOUR WAY AROUND THE CAMERA

One of the first things that uninitiated photographers will be looking for when buying a camera is the number of pixels that the camera uses on an image. These are little dots that make up an image and theoretically the more you have available, the better the quality of the image. However, this isn't where it all starts or ends. Let's try and explain the way around your camera, so that you gain a better understanding of what's important.

Before doing that, you need to decide the kind of photographs that you are likely to take, as this will determine the kind of camera that you buy. For example, will you be taking distance shots of nature or sports? If so, you will need a camera with a telephoto lens. Will you want to use a macro or close up lens? Is there one available for the camera you are looking at? It isn't just about pixels. It's about the features that a camera has in relation to your use of that camera. Do you want a camera that you can carry around easily? Do you want a

compact camera? How easily can you access the zoom feature and how much does the camera zoom in on images? These are important to ask.

The key to knowing your camera lies in understanding its parts and how they work in relation to the kind of photos that you want to produce. In this section, you will learn about the most important parts of the digital camera and what roles they play in capturing beautiful moments. If you have not yet bought your camera, use this section to help you to make a decision on the right kind of camera.

Don't worry, this discussion will not get too technical, but will include just a few bits and pieces that will help you understand how your camera works and find your way around the different features. It's written in a non-technical way on purpose. The problem is that most manuals written by professional camera manufacturers are so technical that most people scratch their heads in dismay and disregard them because they don't understand what is being said. These explanations should help you and be able to improve your understanding of the camera:

The Body –

The body encases the entirety of your camera. While it does not affect the quality of your photo, it plays a huge role in comfort and confidence while you are taking pictures. When buying a camera, look to see if the body looks solidly made because some are very cheap packages that are intended more for the child market. The body should be of a sturdy build and it's worthwhile holding it in your hands to see where the buttons are in relation to your fingers. Some are a little awkward to use, so choose a camera which fits your hand and which has a solid body and a great manufacturer's guarantee.

If the camera features a zoom, see if you can reach the button easily while concentrating on taking your image. Some are a little unwieldy and you miss shots because you are too busy looking for the zoom button rather than planning your image!

The Lens –

The lens is perhaps one of the most important parts of your camera when you are concerned about the quality of photos. The photographic process begins here once the light enters the camera. Some cameras have a fixed lens, meaning you cannot change it. Others have interchangeable lenses and this feature allows you to switch from one lens to another depending on your need. These are particularly useful for professional work or for specialty work such as nature pictures, sports images etc. You also have through the lens or TTL cameras, SLR or single lens reflex and of course, optical zoom lenses, meaning that the lens is built in but that it extends to form a longer lens for close-up work.

Since the discussion about focal points can be too technical, we will just discuss the different kinds of lens and how they affect the photos you will capture.

a. Ultra-wide angle - As the name suggests, this lens can be used even when you are near the target of your photo, but even though you are very close to the subject, the whole frame will still be covered by it. This is useful for taking pictures of large crowds so is ideal for the wedding photographer or those who wish to produce images that incorporate a lot of detail over a wide space. This was the lens I should have had available on my camera to get the whole picture of a rainbow from one end to another. Unfortunately, I hadn't thought I would need one. Think forward because if a camera has this option, it's well worth the investment.

b. Wide-angle - Is almost the same with the Ultra-wide angle, but obviously not quite as wide. This is used for group photographs or scenery where you want to get more into the picture than the simple photograph lens would achieve. It's great for shots from the top of a hill or across a valley because

it gets so much detail focused upon as opposed to being more fuzzy and distant.

c. **Fish-eye** – A Fish-eye lens is most commonly used for added effect, since it will produce photos with curved appearance. This is often used for scenery to distort the image intentionally to give you a really cool effect. In fact, it's worth demonstrating an image taken with this lens so that you get a full picture of what it does. This image is a particularly difficult one to take. Taken in an Art Nouveau style building which is round, it is hard to take an image which shows all the windows together. However, this photograph used a fish eye lens and pretty much achieved it. There are difficult situations when you might use this lens but it's not a high priority if you are strapped for cash. You can always buy a camera that enables you to buy one later on, as and when money permits.

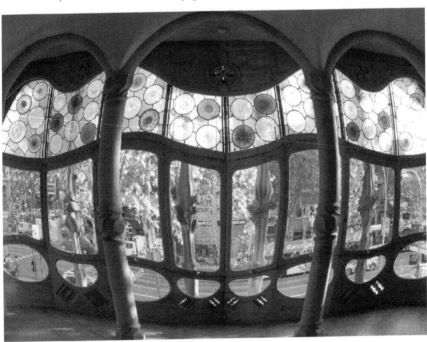

*d. **Standard*** - This also called the normal lens and this is the lens used by photographers when they want their photos to look exactly the way the human eyes can see it. So, there are no effects, and there is no emphasis. However, not all standard lenses are alike. This depends upon the make and the quality of the lens. You can be pretty sure that your standard lens will be adequate if you stick to buying from manufacturers who have a good guarantee and who are well known in the field of photography. Ones that spring to mind straight away are Nikon, Canon and Fuji but there are many more.

*e. **Short telephoto*** - This is the lens used when you want to take a portrait photo. This lens allows you to capture subjects close up without needing to cover distance. Thus, for studio work or a study of a face or facial features, this lens will do the job very adequately. The short telephoto lens comes with a quality camera where you have interchangeable lenses, although in a cheaper camera, this would be covered by the zoom feature that is a general purpose lens for close up work. Look at how much zoom there is if you are buying an integral one as this gives different results. Some of the more expensive cameras actually have a zoom lens that you use much in the same way as you would on an old fashioned camera, in that you turn the lens to focus in on your subject. These are superb.

*f. **Long telephoto*** - This lens is the opposite of the short one, and it is used to capture events that you cannot get close to, such as a sports moment or a long distance sunset. Useful for taking distance shots, these may also be great for candid photography.

Viewfinder

This is the part of the camera that you have to look into to be able to see what your photo will look like. Some digital cameras now are using LCD screens as the viewfinder. It's extremely important that you stand at the shop window and try the screen style viewfinders in natural light. The problem is that many are not built to give you a very good image outside and the reflection of the sun can actually impede seeing what it is that you are about to take a photograph of. Look for those which are non-reflective and which give the same quality of image on the LCD screen no matter what the light conditions. These may have a light shield, which means that the LCD is protected from light, thus enabling you to be able to see perfectly clearly. On some cameras, the LCD screen pivots and this is helpful for awkward shots. Remember, if you cannot see your image clearly with the LCD screen, you are unlikely to take quality images and may just find many of your images out of focus or off center because of the LCD screen letting you down.

The viewfinder on a TTL camera means that what you see is what you get, though on cheaper cameras, what you see is through the viewfinder, while the actual lens that takes the image is further down and to the right or left. Thus, this accounts for why people end up with images which appear to cut off part of the picture, as adjustment was not made at the time of taking the photograph and this is important with cheaper cameras that do not have the through the lens feature. If you do have one of these cheaper cameras, look to see what the difference is between the viewfinder and the actual image that is taken and adjust your camera to get centered results. This usually means lifting it a little, as the viewfinder is invariably at the top of the camera and then moving it to one side, so that the lens sees what it was you originally saw and wanted to photograph.

Memory card -

Most people take this part for granted as it is very small, but remember that this is the part where you will store the photos. The amount of storage capacity and quality of the flash drive is also important. Don't just buy any memory card you can get your hands on. Ask for the best because your images deserve to be kept on a card that gives you the best storage coupled with the best quality. Another point to remember is that you need several memory cards so that you can adjust the quality of your images through the camera menus, to ensure that the images are the best quality possible.

If you don't have a computer slot for your card, you can buy an adapter that will allow you to view your images on your computer screen and this is helpful to look at your images in detail. The USB adapter usually comes with several card options so that if you interchange between one camera and another, this doesn't cause any difficulties. On the back of the camera, they never look as detailed as they do when displayed on the computer screen because seeing them in full size gives you more clarity.

Aperture -

This can be considered as the camera's eyelids, or even the iris. It controls the amount of light that will be absorbed by the lens. Some cameras have fixed apertures, while some have adjustable apertures. The narrowest is f/16 while the widest is the f/1.4. A wide aperture can capture a shallower field (just the subject) with sharpness, good for when your target is close up, while a narrower aperture can capture the subject and the background with sharpness and clarity, good for when your target is far away. This aspect is called the "depth of field."

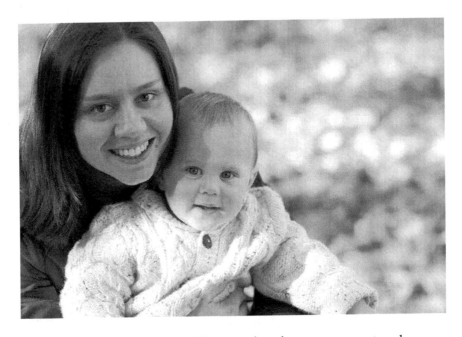

Most photographers take a liking to using the narrow aperture because it brings everything into focus. The only dilemma there is from the use of narrow aperture is that this can result in less natural light. It's also not the best setting to use if you wish to blur the background and make the central figure or feature of your image sharp against that blurred background. If you look at this image, you will see what I mean. This image uses a narrow aperture because the background isn't as important as the subjects in the image although the light reflects wonderfully in the background to give the whole picture a lively look that enhances the image.

Shutter release -

This is the button that you press to be able to take the photos. It is also important to understand about the shutter speed. Shutter speed is the amount of time during which light can enter the camera, or simply the amount of time the lens is exposed to light. Slow shutter speed is often

used for night photography, since it gathers as much light as possible. However, if you want to capture "fast" moments, you might want to have a fast shutter speed. There is a lot of variation with cameras, and many have settings that show you what they are going to do. For example, some allow for portrait work while other speeds are used for close up nature work. Look at the back of your camera as you change the shutter speed and there is usually a good descriptive that comes up in the menu.

Many people don't use all of the features that are on their cameras and that's a shame because manufacturers have built in all kinds of aids for photographers, such as being able to take two images simultaneously – one with flash and one without – so that the photographer can achieve great results and choose the best between the two, leaving the camera to do the work for them. It's a good feature, but it's even better if you learn about using the right shutter speed in the first place.

LCD screen

This is important as stated above. You need to be able to see this clearly in all light, so do test the camera near to a natural light source, to find an LCD screen which shows very clearly what is being displayed. Since the LCD screen houses all of the menus of your camera, you need to be able to see it clearly. It may look fabulous in the shop, but you need it to look every bit as good when you are out on location.

This area is where you can change settings to suit yourself. Many users of digital photography rely too much upon the external buttons and do very little adjustment using the menus on this screen. However, if you want to make the most of your photographic experience, it pays to read the literature that comes with your camera and to play around with the menus to work out the settings that give you the best images in different circumstances. You will be surprised at the amount of features even a relatively small camera can incorporate and that you can only access through the menus displayed on the LCD screen.

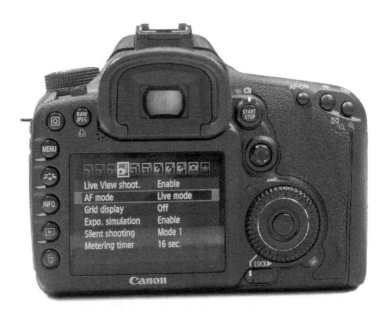

Look at the menu above. This is a typical menu from a digital camera and you have all the options across the top and then all the options within each area to explore. On this particular camera, you can actually use a traditional viewfinder and that's a bonus especially when light is bad.

Flash

The most professional of photographers out there seldom uses flash as they want to capture the natural lighting, but flash can be great help for beginners. It can also help in low light situations where studio lights are not used. Flash simply gives instant light to a scene that you are trying to photograph and can be the cause of red eye. If you have ever seen images where the eyes are red, this is caused by directly looking at the camera or the flash. If subjects turn away a little, this avoids red eye. Flash that is built into your camera isn't the best kind of flash to use if you are taking studio pictures. Having an extended arm with a flash is much better because it deflects the light and even though the

model is looking toward the camera, she/he is not looking toward the flash and red eye will therefore not occur.

Lens Cover

You may see this as being unimportant, though it's vital to keep the lens covered at all times when not in use. If you have a more expensive camera, it would be worthwhile buying yourself a daylight filter that is screwed onto the end of the lens and which will always protect the glass the lens is made from. That way, if you forget to replace your cover, your lens will not get damaged. Filters are much cheaper than lenses and thus this makes sense. If you camera allows for filters, have a look at some of the special effect ones because they can be really helpful to your photographic experience.

Other adjustments and buttons will be available on cameras that allow you to play back your images on the LCD screen, so that you can see pretty well straight away whether you need to take another shot. That's one of the great things about digital photography. Unlike traditional photography which had a film with a set number of frames, digital photography allows you so much flexibility that taking an extra shot really won't use up much space on your card and will help you make sure that you get the photo you are after, even if it takes several shots to do so. If you are going to be taking off the lens cap at regular intervals, make sure that it is affixed to the camera with a string or lead so that you automatically replace it once an image is taken. This gets you into good habits, as it is irritating having a lens cover dangling down when you are carrying a camera.

Extra features which are useful

Tripod slot

On the bottom of a good quality camera, you will find that there is a screw fixing to put a tripod. If taking very detailed photographs and

wanting to avoid any movement at all, a tripod holds the camera firmly while you take your shots. It's also very useful for video shots and will not give the same wobble that a camera will. Some cameras have built in stability control and this helps a great deal though the tripod is the best way to ensure that your shot is completely stable. Choose an appropriate tripod size for the make of camera, so as not to damage the camera by using one with too long a fixing.

Settings buttons

At the top of the camera you will find the area where you can adjust the camera to take different styles of pictures or videos. You also have the option to use manual settings or automated settings. Most people use automated settings until they are more familiar with the camera and what it can do, although there are amazing effects available today allowing people to take not only wide pictures, but also panoramic pictures and the setting for the different uses of the camera lens are changed by this button. Read your manual, as there may be more settings than you think and some may help you out of tricky situations.

Special tones

Sepia toned pictures are very attractive. Inside the camera, there are features that can be accessed via the menu that displays onto the LCD screen. Many cameras these days incorporate the ability to change the quality of the images to get more images onto a card. They also allow for changing the tone of the image to sepia or black and white. It's worthwhile trying different settings and finding out what they do and remember, don't opt for inferior quality images just to pack more onto your memory card. It's better to opt for quality images and have a few memory cards in your camera bag so you can switch quickly when needed. The image below is sepia toned and you can see the richness of tones that makes sepia pictures so very attractive.

Image: Creative Commons attribution: Hauntingvisions.

Look how the sepia tone gives a very old fashioned look to an image. It can be ideal for making greetings cards or for those special family images that you want to keep in an album. Imagine this with a vignette and that's quite possible with many photographic programs on your computer. It's amazing what you can do with your images. Now look at a black and white image and you will see why so many photographers use this as a preference.

Both sepia and black and white images are classic ways of presenting your photographs and as you will see as you read through this book, you can use color as well but the choice should depend upon the overall effect that you want to create. Black and white and sepia are very special ways of presenting images of a certain type and can give really good results, as you will see as you continue on your photographic journey.

The tonal range of black and white photographs veering from exceptionally white through to jet black really can make an image look outstanding. Whether this is abstract in nature or a photograph of a person, black and white really does have its place deeply entrenched in traditional photography as being a medium that is expressive and extremely attractive.

CHAPTER 3

A BRIEF HISTORY OF DIGITAL PHOTOGRAPHY

This chapter will give you a deeper appreciation for the art form, its capabilities and just how far it's come in a relatively short span of time—in fact, proper digital cameras as we know them were only introduced in the mid- to late-1990s, a far cry from their humble beginnings in the late '70s.

The first true prototype began with Kodak, engineered by a man named Steven Sasson in 1975. Sasson grabbed a Kodak movie-camera lens and combined it with some CCD sensors and Motorola phone parts to create something the size of a small toaster oven and weighed about as much as a large newborn baby.

Sasson's prototype could capture black-and-white images on a clunky old cassette tape, but the resolution of 0.1 megapixels was literally unheard of. The first photograph reportedly took 23 seconds to record, to give a sense of how far technology as come.

Of course, Kodak—which would soon fall behind in the digital photography game—didn't capitalize on this early technological feat. Kodak stuck with film all the way, and it would come back to haunt them three decades later.

A few more filmless cameras went through experimentation phases throughout the 1970s, but nothing took off commercially until 1981, when Sony launched a magnetic video camera—the Mavica. An analogue counterpart to film, the Mavica operated on AA batteries, and stored photos on giant floppy disks that could store up to 50 photographs. The light sensitivity was roughly equivalent to ISO 200,

and the shutter speed fixed at 1/60th of a second.

The Mavica launched a brief period of analogue creativity in the camera world, which was followed up by Canon to only some success. In general, analogue cameras cost much more than their quality attested to, though photojournalists put them to good use during major events like the 1984 Olympics, and late-decade events like Beijing's Tiananmen Square protests and the Gulf War. For standard commercial users, paying $1,500 for poor quality didn't make sense.

After the first "true" digital camera was produced in 1981 by scientists at the University of Calgary in Alberta, Canada (it was produced mainly for night sky and space photography), Canon took the helm by commissioning a proper digital camera in 1983, though it never went beyond trade shows—presumably, it was either too expensive, not user-friendly enough or too clunky to ship.

Either way, it would be nearly another decade before digital cameras actually hit retail stores in 1990. It was called the Dycam Model 1, and used a CCD sensor to record pictures digitally and upload them directly to a connected PC.

That same year, a pre-Adobe version of Photoshop was launched, roughly around the same time some entrepreneurs began attaching digital backs to film single-lens reflex cameras (SLRs). The digital revolution, though still in its infancy, had begun to fully take shape.

In the early 1990s, every major tech company joined the fray with more devotion. Kodak launched a camera called the DCS 200 with a built-in hard drive, while Nikon's N8008s offered images in both color and black and white. Apple even ventured forward with something called the QuickTake, a collaboration with Kodak (and later Fuji) that was the first digital camera for under $1,000, but which did not take off.

CompactFlash cards, those large chunky cards that even Canon digital

Rebel SLRs stuck with up until very recently, were introduced in the mid-'90s, with Kodak once again helming the tech charge with its innovative built-in CompactFlash technology in 1996.

But 1995 was the true year for digital camera innovation.

But it wasn't until Casio ventured forward that compact cameras became truly, well, compact. Casio's QV-10, released in 1995, offered a 1.8-inch LCD screen on the back and a pivoting lens. It still used a CCD sensor and stored up to just under 100 color images, but introduced the world to features like the macro preset, auto-exposure and a self-timer.

This was also around the time that movie and sound capabilities entered the picture, bumping up the cost of a standard compact from $1,000 to $1,500. Webcams, too, became commercially viable in 1995, with Logitech spearheading the territory with its VideoMan product.

Canon's now-infamous PowerShot series took flight shortly after all this technology was introduced in 1996. It boasted a larger CCD sensor than most others before it (832x608 pixels), as well as camera mainstays like a built-in flash and optical viewfinder, not to mention auto-white balance and an LCD screen on the back. In other words: it was what we understand today to be what a digital camera. Canon also figured out how to drive costs down, so they could charge a cool $949 at the start.

Since then, Nikon's CoolPix and Sony's CyberShot series became serious contenders, while Fuji, Olympus, Kodak, Casio and Panasonic would rise and fall to varying degrees throughout the next two decades. But commercial digital photography—the basics of it—is not even 20 years old, as of this time of writing (in 2014).

That means that everything in the last two decades—every digital SLR, mirrorless camera, phone cam, filter and app—all came flooding in a very small span of time.

We can then understand digital photography as a recent art—even though photography is a much older one, the ability to produce magical digital artscapes, put images into Photoshop and play around, and combine exposures quickly with methods like multiple digital exposure and HDR, are all relatively new experiments.

Photographers are still figuring this game out. Even the best in the business haven't been doing it as long as you've been alive. That gives you an advantage, really: even if you're just starting out in the world of digital photographic art, you're not nearly as far back as you think.

CHAPTER 4

THE INS AND OUTS OF DIGITAL SLRS (APERTURE, SHUTTER SPEED, BALANCE)

To take good photos, you need to understand good camera gear. Even if you're not using an industry-standard kit at the top of the line, you've got to understand what distinguishes a good digital SLR from a great one.

While it's true that no amount of technical knowledge can match up to natural ability, the opposite also holds true—no amount of raw talent can teach you the fundamentals of what is, at its core, a very technical art form. Even if you plan on breaking the rules, it's imperative to at least know them first.

In order to properly control what's in your foreground, background and center, you'll need a basic grasp of how the manual functions of an SLR work. It's not too hard—we'll go through it here.

Appreciating Aperture

Aperture confuses a lot of beginners because there are so many phrases that ultimately refer to the same thing: aperture, f-stop and depth of field are all pretty much synonymous, and that's not obvious to a beginner photographer.

Here's how it works: you adjust your **f-stop** to control your **aperture**, which affects your **depth of field**. So, on a purely technical level, you're only really dealing with f-stops on the screen of a camera.

Think of **f-stops** as the tool, like a hammer and nails that controls your **aperture**, which is your building material, like wood. When you

use your tool to physically manipulate something, the ultimate result is the product—metaphorically, a house; photographically, the **depth of field**.

Starting With F-Stops

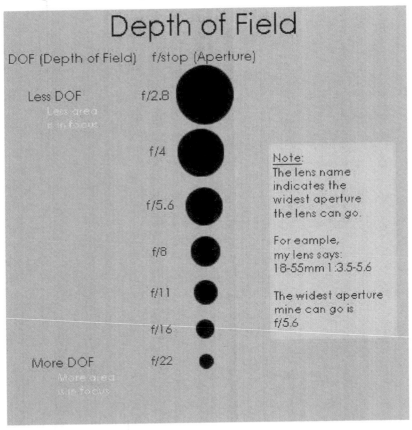

On most lenses, f-stops generally range from 4.5 to 8 or so, but various lenses will emphasize low-light conditions, offering f-stops as low as 0.5 or 1.2.

Still following? Good. But your next question might be, "What does all of this mean?" It helps to work backwards.

F-stops ultimately control your shot's **depth of field**, which is itself measured as "shallow" or "deep". A deep depth of field means everything will be more in focus—including the background and foreground almost equally. A shallow depth of field means that your subject will be in focus, but your background won't be; this is what's called "bokeh", when the background of an image is gently blurred. The quality of many high-end lenses is determined by the quality of their bokeh.

It helps to think of this one, visually, as a standard school ruler, from one inch to 12 inches. Focal length refers to what's actually in focus. If your depth of field is shallow and your focus is two inches away, whatever's sitting at six inches and beyond won't be in focus. But if it's a deep focal length, you can range what's in focus from two until maybe eight inches.

The wider your aperture, the shallower your depth of field—f/1.2, for example, is a very wide aperture, so your camera lens will be big and open, also letting in a lot of light. You'll have to fiddle with your ISO and shutter speed to find a balance so the shot isn't overexposed. (We'll deal with overexposure soon—for now, know that it just means "too bright.")

If you want a deeper depth of field, you'll need a narrower aperture—something like f/16, which will create a consistently detailed image.

When to Shoot Shallow, and When to Wade in Deep

When capturing cities and landscapes, deeper depths of field are more desirable so every detail of the frame appears in focus. This calls for a narrow aperture, or *high* f-stop.

A standard f-stop is f/8, which has birthed a classic photojournalism maxim: "f/8 and be there." It means that, as long as your camera's set to f/8, all you need to do is show up to the scene and your shots will

turn out, at the very least, decently.

If it sounds like an oversimplification, you might be underestimating the importance of aperture. When you see a rich landscape photo, you need everything to be in focus. Some professional landscape photographers will leave their digital cameras on "aperture priority" mode—that allows you to control the aperture only, and adjusts the shutter speed and ISO based around that. This is ideal because aperture is the most important part of landscape photography for most shooters—otherwise, even if the shot is framed and lit beautifully, if the foreground trees are in focus and the background mountain isn't, the shot is irreparably ruined. You can fix lighting in Photoshop, but you can't fix focus.

Portraits are another form of photography that demand crucial attention to depth of field, but in a different way: rather than in landscapes, where everything should be in focus (that's a *deep* depth of field), it's better for portraits to have a *shallow* depth of field—that way, your subject will be in crisp focus, while the background will be gently blurred. If the bokeh is smooth enough, the portrait will strongly emphasize the foreground and allow the viewer to pay attention to what's important.

Macro shots, like super-close-ups portraits of flowers and insects, are also aided by shallow depths of field for the same reason. If you're shooting a flower close up and there's a bug flying in the background, you might not want your audience to notice it—you'll want the flower to pop out of the foreground.

Other types of photography, like wildlife and sports photography, won't be as affected by your chosen aperture. In those cases, because *movement* is the key aspect to control, shutter speed is much more dominant.

And if you're not clear on what exactly shutter speed is, well—you're in luck.

Setting the Shutter Speed

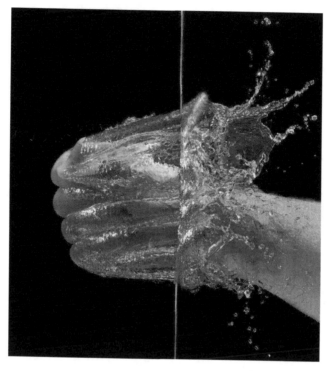

A camera **shutter** is the photographic term for the part of the lens that opens and shuts, so the **image sensor** can actually see the picture you want to take. **Shutter speed**, then, is the length of time that the shutter stays open for.

If you're working without a tripod, just holding the camera in your hands and pushing down the shutter button rather than using a remote, your shutter speed will commonly range from 1/100th to 1/500th of a second.

The fractions in these numbers can be confusing, and camera newbies just starting out often get the system backwards, because they see the "500" and assume that's a larger number than "100".

In fact, 1" represents one second, and 1/500" is one five-hundredth of a second—meaning 1/100 is a longer exposure than 1/500. A very long shutter speed would be anything from 1" to 30", which you'd only use if you had a tripod, probably shooting at night, and were wanting to achieve an extremely fluid and surreal effect.

But I'm getting ahead of myself. Beyond the numbers, shutter speed is actually a pretty easy concept. The longer your shutter is open, the lighter and potential motion your photo is exposed to. This is great at night, when there isn't a lot of light and you want to let as much in as possible—you can turn a sliver of moonlight into a mystical blaze. But you'll need a tripod or sturdy surface, not to mention a remote control, because your hand probably won't be able to keep the image steady for the full time, and even just pressing the shutter button down with your finger will cause it to shake around.

During any shutter speed longer than 1/60, shooting without a tripod and remote is risky, because the shutter will record every shake and gesture your hand makes, no matter how subtle. Using a flash can help, but if you're in a dark space where you can't move around that much—like a concert or even just in a crowd at a festival at night, where you can't hold still very easily—it's easier to rely on other factors to brighten up the image, like aperture and ISO. (We'll get to that one in a minute.)

Still grappling with the concept of shutter speed? Here's a visual metaphor for you:

Think of your camera as tightly sealed box, and light as a gas. If you open the box for 1/800th of a second, you'll barely let in any gas. If you leave your box open for 1/100ths of a second, you'll let in way more gas—eight times as much. If you leave your box open for two full seconds, your box will probably fill up with gas entirely.

Remember, here the gas is light and what comes inside the camera-box is the image you'll ultimately produce. The more gas, the lighter

the image, and the more stable it will have to be.

Different Shutters for Different Scenarios

Shutter speed gives you a lot of room to move around as a photographer. Landscape and cityscape photographers won't often adjust the shutter speed, because they might leave their cameras on Aperture Priority

mode. The only time you might adjust the shutter speed is if you want a long exposure shot of something—this is extremely common with water-based shots, like shots of waterfalls and rivers.

The opposite effect—stopping a waterfall in its tracks, so you're able to spy every last splashing drop—would require an extremely quick shutter speed, like 1/1000.

That said, for landscape and cityscape photography, it's often better to worry about shutter speed when you're shooting without a tripod or if you want to blur the motion of something. For faster shutter speeds, lower the f-stop. For slower shutter speeds, widen the f-stop.

When shooting still shots, like portraits and architecture shots, shutter speed matters less, unless, again, you want to blur the motion surrounding the object itself. Often, a simply shutter of 1/200 or 1/160 would be fine.

When you're shooting quick movements, like sports or concerts or even kids running around at a birthday party, a quicker shutter speed is essential, or else everything in the shot will be in focus except the kid himself—he'll be a moving blur of fog, like a ghost.

A Quick Note on Blurred Images vs. Image Stabilization

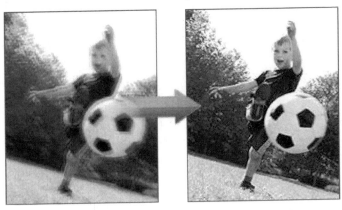

Some people mistake what motion blur is, or how it's caused. Motion blur has nothing to do with Image Stabilization—that, often shortened to IS, deals with the movement of the lens itself, caused by the inevitable shaking that comes with holding out a long object. When you try to capture a running child and you use image stabilization, you won't notice a difference; the kid will be a blur. The only way to capture the kid crisply in motion is with shutter speed.

Isolate Your ISO

The last major photo factor is ISO speed. This controls how sensitive your camera sensor is to light. It is a crucial control to image quality and is very important to understand for variable lighting conditions.

The most important thing to know about ISO is that raising it causes "noise" to creep into your images—the higher the ISO, the more noise in your images. Noise is the digital equal of film grain and essentially lowers the quality of your images. In your image, noise will be the visibility of what are essentially tiny little colored dots.

When shooting outdoor architecture and landscapes during the day, it's easiest to leave your camera on the lowest ISO possible. In direct sunlight, that's usually ISO 100, or something around there; some cameras will allow you to go as far down as 50.

When shooting indoors, you'll need a higher ISO—anything higher than 1600 becomes susceptible to noise, though if you're shooting with a really strong camera, you can go up to ISO 6400 without any significant problems. (At a certain price point, the smoothness of a camera's high ISO performance becomes a top selling point.)

But sometimes raising the ISO is necessary even outdoors, too— often in cases where you need a quicker shutter speed, which would otherwise explode the image with brightness. Some examples when raising the ISO can help include:

- If it's unexpectedly dark and you're caught without a tripod, a high ISO—even if it gets a little grainy around 3200 or higher—can be a saving grace, because raising the ISO can help you achieve faster shutter speeds (which would otherwise make the image turn out too dark), so you can take shots handheld without them turning out blurry.

- If you're photographing traffic late at night and you want fewer light streaks from headlights, raising the ISO will allow you to use shorter shutter speeds to sharpen up the image.

- Many outdoor photographers don't like using flashes very much, but even indoors, a high ISO speed can allow you to take photos in dark or indoor conditions where other photographers are using flash.

- If you are in a windy area taking sunset shots, longer shutter speed shots are more susceptible to camera movement from wind even on a tripod, might as well take some shorter shutter speed shots at a higher ISO speed just in case just to make sure you get a sharp one.

- If you are in a busy area of a city and people are bumping into your tripod and the ground might even be shaking, raising the ISO speed in order to use faster shutter speeds can help.

The Delicate Art of Light-play

As you might be able to tell by now, photography is a balancing act—you need to balance the aperture, ISO and shutter speed to achieve a perfect balance of lighting, while stressing whichever of the three matters most in that situation. The only way to get a good grasp is by playing around with the settings until you figure out which one works best for each scenario.

Balancing Your Whites

Every light is tinted a different color—you just might not be able to see it. You might notice that taking photos on cloudy days produces a bluer tint than normal, or that shooting under a canopy of trees will tinge your whole shot green.

That's called color casting, and it's what happens when light is absorbed by certain colors and bounced back out. Cameras can detect this casting; our eyes can't.

The answer is to tweak your camera's white balance. While every

camera comes with an Auto White Balance (AWB) setting, and AWB is often pretty effective, sometimes it misses the mark, or produces a compromised grayish quality. I usually leave my camera on AWB on days with unpredictable weather or simple lighting, but if the weather is consistent, it's best to stick to a single weather pattern.

The Different Types of Lighting

For outdoor shots, white balancing options include daylight, overcast and shade (shadier tends to be bluer), although some cameras offer special presets for snowy scenes and beaches because the whiteness of the sand and snow tend to blind the sensor. There's also a white balance preset for when you use the flash, because a camera flash will also tint a scene towards the yellowish/reddish scale.

Indoors, you'll find two common light bulb options, tungsten (yellowish tint) and fluorescent (greenish/bluish tint).

Auto white balance can often detect these differences pretty well, but if you wanted to color-cast your shot even in normal light, giving it a blue or red tint, it's important to be able to immediately detect how different light settings affect different scenarios.

Setting the Metering Mode

Even when photos look bright, eyeballing a shot can only take you so far. Light, especially for when you're printing photos, should be an objective, scientific measurement. Light meters take care of that.

Metering is what your camera does when it judges an amount of light to decide on a shutter speed and aperture. Film cameras never had this—photographers needed an external light meter to judge how bright a spot was. Now, every camera has a built-in light meter. (Although professionals still use external meters when precision is key; this is partly a result of them being stronger and able to detect the strength of light falling on the subject rather than in-camera, and partly an old

habit of some film users.)

The Metering Types

The three types of metering are evaluative metering (a Canon term; Nikon users know this as "matrix metering"), center-weighted metering and partial metering, a variant of spot metering.

Evaluative (or, again, also called matrix) metering is the common one. Many photographers of all stripes leave their cameras on evaluative, and you likely will also. Evaluative metering casts a wide net of potential lighting options and segments them into zones, after which it finds your focal point and measures the light of the entire frame based on that, often accurately.

Center-weighted metering does what it sounds like: it weighs the center of the frame as what should be most in the light, and disregards the surrounding image.

Spot metering, conversely, does the same but with a smaller portion of the center frame, usually just a small spot in the center of it. This makes it easier to capture non-moving objects, when you have time to set up the shot.

Partial metering is similar to spot metering but acts a little bit more broadly. It's easier to set up shots quickly, but would also be best for backlit photos—say, someone standing against a sunset. You'll have to frame your image carefully, but they're better options for when you want to ensure that a centerpiece is lit up, regardless of the surrounding imagery.

Stay Focused—How and When to Use Manual or Automatic Focus

It takes years of shooting to train your eye to identify what's in focus versus what isn't. As a result, most photographers just starting out tend

to leave the focus on automatic and not worry about managing it.

But autofocus isn't perfect. A lot of times, autofocus has no way of knowing what you want to focus on. If you're shooting a flower in front of a mountain range with a very shallow depth of field, you might want to focus on the flower, but your camera might easily assume you want the mountain in focus.

There are three preset ways to control autofocus: all points focus, flexible focus (also known as multi-point) and center point focus.

Center point focus is the most common, and the one photos use the most. It means you've got to first center your image, then press the shutter down halfway to lock whatever's in the center of the frame in focus. After that, as long as you don't take any steps forward or back, you can adjust your camera around to arrange the composition however you like.

All points focus is useful for moving objects—animals, sports, or anything that would make it impossible to center and set up a composition. In landscape and cityscape photography, this isn't as common, but it's good to use if you want to snap any street shots or animals while you're out on a shoot.

Flexible focus is a hybrid of the two, wherein you're letting your camera decide which of the focal styles to use—a centered style or a multi-point one. This would be useful if you're not sure what you're going to find in a landscape shot, and you want to be prepared for anything.

Focusing in Low Light: An Invaluable Trick!

Auto-focusing at night is extremely difficult, because cameras can only focus properly in bright light. (That's why flashes are necessary.)

One way to ensure a tight focus at night, or any time your autofocus

is on the fritz, is to switch to manual focus mode and turn on your camera's Live View screen option. Zoom all the way into a shot using the screen and focus it that way—as long as the edges are sharp, once you zoom back out, it will stay that way.

Long Exposure Blurs? Ditch the Image Stabilization

When it comes to long exposure shots, image stabilization may be your worst enemy.

The problem happens when the IS motor will suddenly detect its own vibrations, causing the tripod to shift and subtly amplify the movements. The quality of tripod or camera doesn't matter—it's just a weird glitch in the physics of digital photography.

The end result will be fuzzy, but you can solve the problem by turning off IS on long exposures—which you don't even need anyway, since you're using a tripod.

The DL on RAW vs. JPEG

Before you even begin to set up a shot, you'll have two output shooting options: do you want your files to be in RAW or JPEG?

The answer is RAW. It's pretty definitive, actually, if you're trying to be a professional at all. (Or even aiming for professional-grade photos for fun.)

The difference is simple: RAW files are enormous and richly detailed; JPEGs are smaller and quicker to work with. JPEGS are fine if all you want is to upload shots directly onto Facebook, but if you're planning on doing any post-production in Light room or Photoshop, RAW is the way to go.

I used to use JPEGs because they were smaller and uploaded faster to my computer, but the advantages of RAW outweigh that too much. On

a single exposure, a RAW file produces a much more flexible ground from which you can edit color, contrast and light.

RAW is the preferred format for professional photographers of any style, but it's especially useful for landscape, cityscape and architecture photographers who want to make large prints. That's because RAW files are much more technically complex and rich: they're 12- or 14-bits instead of JPEG's 8, which encompasses over 4,000 color shades—significantly more than 8-bit shots' 256 colors.

When editing a colorfully rich landscape shot, you want a bit of leeway when it comes to post-production. Adjusting levels in a RAW file makes for a much smoother, more natural editing process than when the actual composition of the photo is smaller and rougher.

Stay Safe: Bracket Your Exposures

Exposure bracketing is kind of a luxury. If you have the time for it, it can save you a tremendous amount of pain and time spent digital retouching after the fact.

Exposure bracketing does what it sounds like it does: it means you're bracketing your shot with two others, one over-exposed and one under-exposed. The idea is a safeguard and can also prep you for a high dynamic range image if you decide to go that route in post-processing. You're protecting yourself against your camera's auto-exposure settings.

The idea is that your camera's light meter, if you let it automatically select an aperture and shutter speed, might get the light wrong—it could see a skier standing in a field of snow and exposure the shot so the snow doesn't seem so blindingly bright, which in turn transforms the skier into a shadow. The opposite may also be true, and your light meter may incorrectly assume a shot is too dark when it's exposed the way you want it to be.

And what if the shot is a one-of-a-kind opportunity? You can't risk over- or under-exposing your shot, so you'd bracket it between two safety shots: one possibly over-exposed, and one possibly under. For really great shots I often blend the best attributes of each of the bracketed shots together for a high dynamic range image so everything in the photo is perfectly exposed.

For standard shots of landscapes, portraits, architecture and sports, the industry standard is to take three bracketed shots (-1, 0, +1).

When dealing with vastly varying light degrees, it's nice to bump that number up to five shots, with two brackets on either side (-2, -1, 0, +1, +2). Because cities tend to offer a lot more light spots and dark spots—especially at night, when shadows and bright lights contrast in swirls—it's good to have the balance available to you, especially when bringing the shot into post-production.

Usually, if the original shot is good enough, photographers can work with that alone in Light room or Photoshop and not bother with the bracketed ones. This isn't always the case, which is why it's good to have a backup—you can never really tell until you upload them on your computer afterwards. I sometimes find myself processing one of the higher exposed bracketed shots instead of the primary exposure because the extra light often makes the final result more dramatic.

But, like I said at the beginning: exposure bracketing is a luxury. If you've got the time for it, it's nice; if you're on a brisk schedule or can't stop every time, though, it's fine to just take one or two shots and not worry about setting up your tripod to take multiple exposures every time.

Use That Self-Timer

Typically, when we think of using the self-timer, we think of family gatherings where one guy sets up the shot, sets the timer to five seconds

and rushes into the frame with only a second to spare.

But professionals can use the self-timer also, and not just for self-portraits. The benefit is that the self-timer takes a shot regardless of whether you're pushing a button—and, when it comes to things like long exposures or bracketed shots on tripods, you need the shots to be identical and unmoving.

Try setting up a shot with a two-second self-timer to avoid any motion blur from your finger touching the shutter. This technique is also useful for handheld HDR shots during the day or dusk, because the self-timer can be set up to take multiple shots in a row. Again, bypassing any possible motion blur is a huge benefit here—whenever you can avoid touching the camera to take a shot, it helps.

The Bare Necessities

That's all for this chapter! It might seem like a lot, but in truth, it will all become second nature soon enough. The trick is to get out there and shoot, shoot, shoot as much as you can, and the natural knowledge that will flow from that will soon become secondhand.

Don't be intimidated if you don't understand certain aspects yet—if you're ever in need of more clarification, turn to a photographer friend or go online to messages boards with questions. People are generally helpful and kind to newcomers with courteous, honest questions.

CHAPTER 5

MODES AND EFFECTS

There are various automatic modes available in a DSLR camera to help establish ideal camera settings for various conditions. Professional photographers can take their best shots by experimenting with these modes of shooting. Here are some of the common shooting modes available to use with your DSLR camera.

Portrait Mode

When taking a portrait, you want to ensure that your subject's face appears natural in the foreground. Therefore, you need to blur the background. The camera will adjust to a larger aperture, and the depth of field will be narrowed allowing the subject's face or smile to be detected and captured. Separation of the subject from the background requires use of the zoom function. By zooming in on your subject, they become separated from the background, and a perfect portrait can be achieved. The camera may also use a fill-in-flashlight when in sunny conditions to reduce shadows. To take a portrait at night while retaining nighttime atmosphere, you can use the night portrait mode. This mode applies a low shutter speed and flash to capture light in the foreground and background of the scene.

Landscape Mode

A maximum depth of field is needed to capture a landscape. The camera will, in turn, select a small aperture to create that effect. This will create a well-focused image through the entire depth of the scene. The shutter speed will also slow down, allowing more light to enter the camera lens. If the foreground appears dark, the camera will use the flash to properly capture the colors.

Macro Mode

Macro mode can be used when you take close-ups and photos of small subjects such as insects or flowers. A narrow depth of field is created with large apertures and a fast shutter speed. This will blur the background and create a crisp image of the subject. You can use a macro lens for your DSLR camera to help you focus on the subjects. A tripod is also recommended to steady the camera for a sharper image.

Sports Action Mode

You can use the sports action mode when shooting moving subjects engaged in fast-paced activities in bright environments. A larger aperture and narrow depth of field is applied with this setting. Additionally, a fast shutter speed minimizes blur by reducing the time available for a subject to move in the photograph. Finally, this shooting mode also allows you to take a series of consecutive images in order to avoid missing out on a good shot.

Panoramic Mode

This panoramic mode allows of the photographer to capture multiple images and stitch them together to create one large image. You can use this mode for images of tall buildings or wide landscapes. The exposure and focus buttons are locked after the first photo to ensure consistency and create a well-focused, final image. To achieve this effect, you move the camera in a horizontal or vertical direction while pressing down the shutter speed button. A panoramic image is created automatically.

Creating a Silhouette

A silhouette is a photography technique that can portray the emotions of the subjects and engage its viewers. This is an important technique for any photographer to master. The effect can be created naturally by

using sunlight or another source of back lighting. The aperture should be large, around f8, creating a long exposure time. You should have your subject stand on a beach during sunrise or sunset. Make sure that the sun is behind the subject, and take a shot. This will create an image with an exposed ocean background and a black silhouette of the subject.

Red Eye Reduction

Red eye is caused by use of the camera flash when a portrait is taken in low light. The flash reflects of the subject's retinas, making the eyes appear red. Photographers use the red eye reduction feature in the DSLR camera to reduce the redness and make the eyes look natural. This feature causes the camera to give off two flashes when taking photographs. The first flash is illuminated before the picture is taken, causing the irises to contract before the second flash is illuminated with the shot.

Black and white effect

Photographers prefer using black and white in low contrast settings, such as on an overcast day. Taking a black and white photograph will maximize the contrast to improve the appearance of the whole picture. Without color, the photographs are viewed in terms of shapes, textures, shadows and highlights.

Use of Spot Metering

Optimal image exposure can be achieved through the spot metering technique. This technique concentrates on the lighting around your focal point while ignoring everything else. A photographer uses this mode in their DSLR camera to optimize settings for the part of the scene they consider most important. You should use it when your subject is much darker or brighter than the surroundings and takes up a small portion of the frame. For instance, in bird photography,

the birds generally occupy a small area of the frame and need to be properly exposed. Additionally, taking photographs of the moon is most effective when using this technique since it usually occupies a small area and is surrounded by darkness.

CHAPTER 6

WHAT MAKES AN IMAGE POP?

Every photographer's dream is to create unique images that become the center of attention. To be able to do so, your image has to have a deeper meaning and an aesthetic and emotional appeal to the viewers. The positioning of the image, layout, color and lighting combine to make your image stand out from others. Here are three vital rules of creating outstanding images.

Focal Points

Every image must contain a focal point. The focal point is anything that you want to stand out from the rest of the image. Focal points act as a basis of great composition because they enable the significant elements of the photograph to work together to achieve the best effect. It is important to ensure that the point of focus is clearly portrayed in order to avoid misunderstandings from your viewers. When the right focal point is achieved the image will look stunning.

Rule of thirds

Novice photographers often feel the urge to put the focus in the center of the image, but this tactic does not always produce the best image. When subjects are placed at the center, they appear static. Placing the focus using the rule of thirds creates the appearance of motion and a more natural setting. The rule of thirds involves the placement of subjects within a frame to achieve a balanced image, but it discourages using the center of the frame as the focal point. In the rule of thirds, you split your image into nine equal parts by using a three-by-three grid. The image is therefore divided by two vertical and two horizontal

lines to form four intersections. The rule is to place the subject over one of the intersections. Here is an example of placement using the rule of thirds. Notice how the frog seems as though it is about to move.

Context

Put simply, context is the setting or location of the image. For example, the context can be in a market place, home setting, or at a national park. The context of an image enables understanding of what the image is attempting to communicate. It also makes the image interesting and exciting to look at. Understanding the context of the image will help you decide which camera settings to use and the proper angle for taking the photograph.

CHAPTER 7

HOW TO COMPOSE AN IMAGE AND PUT IT IN THE RIGHT FOCUS

Composition is the process of organizing the visual elements and details of subjects in a scene to create an artistic and balanced image. Every photographer has unique composition abilities, as they are able to visualize their subjects differently. In every composition, there is always a message that is conveyed. The viewers interpret it in their own way. If the viewer's interpret the meaning of the image incorrectly, then the image composition ceases to be effective. Therefore, you should always communicate a clear message to your viewers in order to gain interest in your composition and avoid misunderstandings. We are going to look at elements such as lighting, color, location, lines and depth of field to understand how they lead to a nice composition.

Lighting

Lighting is a very important tool in photography, and it plays a large role in composition. Both light and darkness can take part in the composition. For instance, photographers usually put more light on to important subjects while the unimportant subject is less illuminated. To ensure you make the most of natural light when indoors, you can move your subject close to a window. You can also create a dramatic effect in portrait photography by lighting one side of the subjects face and leaving the other side dark.

Depth of Field

Depth of field refers to the distance between the farthest and nearest objects that appear in focus. This varies depending on the aperture,

camera type and focusing distance. Normally, the depth of field is determined by the apertures with an aperture of f/2.8 being wide and an aperture of f/22 being narrow. A wide aperture will offer more depth of field when focused on a subject that is far away than when focused on a subject that is close to the lens. When you want all the objects in the scene to be in focus, using a large depth of field is required. However, when you want the focus to be on the subject alone, a low depth of field is applied. This will cause the foreground and background to blur.

Location

Location is an element with huge composition potential. It helps to show the subject's environment and gives clues about its life and character. It can bring dramatic effect, create parallelism and contrast, and help in defining our subjects. For instance, a photograph of a mansion taken in a leafy suburban area suggests that the people who live there are rich compared to a photograph of shanty houses. Simply put, location acts as the backdrop of a photograph. Choosing unique environments will create the best composition.

Color

Colors are what make an image appealing and catch the viewers' attention. Colors are good elements of composition as they are used to convey different meanings of an image. Each color has a meaning assigned to it. For example, red stands for danger, white implies purity, and green represents growth. If you understand your subject and the story behind it, it will allow you to understand the colors you should use. For example, a picture of heaven is usually portrayed in white color whereas hell is portrayed in red. In the end, colors give the image a balanced appeal.

CHAPTER 8

THE BIG GUIDE TO CAMERA GEAR (HERE'S ALL YOU NEED...)

A true professional photographer isn't inhibited by their equipment. I'll use a digital SLR when I can, obviously, but if there's a gorgeous, spontaneous photo op and all I have is my iPhone, I won't hesitate to capture the moment.

The trick to good photography is in seeing the world as a series of potential photographs, as seeing the art in everyday imagery. It's all in the angles and lighting. Once you're able to do that, you can capture any moment somehow—even if it's not what you have in mind, you can capture a shot as well as anyone could.

In this section, we'll go through some of the main gear expectations most professional photographers' deal with. Don't feel obligated to buy all of it, especially all at once; your gear will be an ever-evolving stream of equipment that you'll buy, sell and upgrade over years and years. But it's important to know what's out there.

The Myth of Megapixels

There are a lot of technical specs to sift through when buying a new camera body. Before we get into the exact types, there's one myth we need to dispel first: the myth of megapixels.

Professional photographers know that megapixels aren't nearly as important as consumers are led to believe. Image sensors and low-light performance are much more crucial factors when choosing new gear.

The biggest reason to pay attention to megapixels is that a higher megapixel count will increase the image's resolution—meaning the image itself will be larger. This is especially useful if you shoot wide but plan to crop in later.

Digital SLRs

Digital SLRs are the product of choice for professional photographers. SLR stands for Single Lens Reflex, which essentially means you can detach the lens and screw on a different one. This is what distinguishes SLR cameras from compacts—an SLR is much bigger and heavier, and offers photographers much more leeway and variety in what kind of shots they can take.

When it comes to choosing a DSLR, there's no right or wrong decision. It depends entirely on your own personal preferences.

The two giants of the DSLR world have long been Canon and Nikon. In the world of entry-level DSLRs, The rule of thumb is that Canons generally skew towards lighter, plastic bodies and user-friendly interfaces, whereas Nikons are heavier and sturdier, built with more metal parts and an appeal towards a certain devoted crowd. I personally shoot with a Canon, but mostly because I started out with a Canon Rebel, and began investing in Canon gear from there. Today I shoot with a Canon 5D Mark III, but I defy you to figure out which of my shots came from the Rebel and which from the 5D.

Sony is something of a newcomer to the DSLR world, but is rapidly becoming a strong contender in the market with quick speeds and small, light bodies. Many will swear by them for their commitment to the German lens manufacturer Carl Zeiss; others find that Sony cameras feel like plastic toys, are far too light and counter-intuitive. It's an ongoing debate. Olympus, too, is a unique camera company in that its DSLRs tend to gear towards niche photographers and hybrid camera models.

Full-frame or cropped sensor?

Camera models come with sensors cropped to various sizes. The sensor is the part inside the camera that actually captures the light of the image. When a sensor is "full sized," it means that what you see through the viewfinder is what you'll get—the final product won't be cropped at all.

Cropped sensors are more common in less expensive Digital SLRs. Cropped can mean a few things, but it usually images the image is being cropped anywhere from 10–25 percent. So even though you see a full image in your viewfinder, the edges will be cut out when you view the file after capture.

The basic benefits of each are clear: full frame cameras are more expensive than cropped frame cameras, not to mention being larger and heavier. If you're buying a full frame camera, you're making a big investment.

But the benefits are myriad beyond just that one simple fact. A full frame camera is a great investment for any photographers, whether he or she is shooting

Here are some other features you should look for in a DSLR:

Mirror lockup

SLRs offer what's called a mirror lock-up, or MLU. This locks the camera's internal mirror in the "up" position before the shutter is pressed, which noticeably reduces the amount of movement in the camera itself.

Basically, just by taking a picture, a digital camera will vibrate. When we think of shakiness in a picture, we usually associate it with not using a tripod. But even using a tripod and pushing the shutter down with our fingers causes a great deal of blur.

The way to avoid this is with a remote control and tripod set up, but *even this* requires the mirror to snap up, the aperture to open and the shutter curtain to expose the sensor. All those little machinations cause the camera to vibrate all by itself—even without a person touching it.

Mirror lock-up reduces that to the least amount of movement possible, allowing your camera to remain virtually still while snapping shots on a tripod. It's a great tool for long exposure shots and quick multiple bursts.

Exposure Bracketing

These days most DSLRs will have something called AEB—Automatic Exposure Bracketing. With AEB, you can take usually up to three shots with a single press of the shutter, with the two "extra" shots as safeguards for what you believe to be the correctly exposed shot—just in case it isn't. You can adjust the exposure settings of the bracketing shots, too. Bracketing is also an important feature for doing HDR photography.

Some DSLRs are unique in that they offer AEBs that snap up to five bracketed shots or more. For cityscape photographers especially, this is a handy tool, due to the wide ranging light intensities from streets and buildings at night.

Live View

When Live View debuted, it was widely seen as a dumbing down of "true photography"—the distinction between DSLRs and compact cameras was always that, to use a "real camera", you had to use the viewfinder.

Since then, Live View has grown into an essential tool for photographers of all stripes.

One of my favorite uses is manual focus at night. With so little light,

the bright screen is invaluable for zooming in and adjusting the focus at 5x or 10x magnification. It's like having a 10x loupe magnifier built into your camera.

Some cameras now have tilting screens, too, which are useful for awkward angles that render the viewfinder useless. Abnormally high or low angles are ideal for popping out the screen to look at it from wherever you're standing.

High ISO Image Quality

A great determiner of digital camera quality has always been high ISO performance. Low-quality cameras are marked by their noise—the grainy quality images suffer from when taken in extremely dark light with a high ISO like 3200 or 6400.

Stronger cameras with stronger sensors will overcome this noise problem with crisp high-ISO performance and low grain. When flash and tripods aren't viable options (like at some concerts, for example), high ISO is the only option.

Larger sensors, in general, allow for more light to be let in, which create all-around brighter, more focused pictures. If your image does wind up noisier than you'd like, you can also turn your image around and own that style: play with layers and saturation levels in Photoshop and the grain can wind up looking like a more natural filter.

Beyond the SLR: Looking Into the Mirrorless

Arguably the biggest recent impact on digital photography has been the production of mirrorless cameras. A mirrorless camera produces the same image quality as a DSLR, but within a fraction of the weight and size.

They can afford this by removing the mirror from digital SLRs—the thing that we discussed above, which is a remnant of film SLRs

and takes up as much bulky space as the sensor itself. In this way, mirrorless cameras are the way high-end digital cameras *should* be made—as small as possible to be more efficiently created.

The pros of mirrorless cameras are obvious: the size and weight make traveling a breeze unlike ever before. They are also, in theory, cheaper to make, because they use so many fewer mechanical parts. Such fewer parts also mean that there are fewer opportunities for vibration—no mirror means no need for Mirror Lock-Up, and less noise to boot.

But the mirrorless models are new, and the product still has some kinks to iron out. The biggest one is battery life—between the smaller battery and constant live view, the most common complain across the board for mirrorless cameras has been about how quickly the battery dies.

The second most common complaint is about that little thing I just mentioned, the constant live view; another casualty of downsizing the DSLR has been the optical viewfinder. Many mirrorless cameras don't have one, so while the LCD screens on the backs of such models have been brighter, seeing them clearly in sunlight is still a trial, and they use up more battery life whether you like it or not. Some models offer electronic viewfinders, which suffer from a slow lag response or high-contrast manipulation (to ensure visibility, but not accuracy of color).

There are a few more pros and cons to each, including autofocus system and sensor size, but fans of each will point out cons of the other. The biggest definitions are stylistic ones: do you want a camera that's smaller and easier, or bigger and occasionally more able? Neither choice is wrong.

Through the Looking Glass: Choosing Lenses

It's hard to overstate the importance of a good lens. If bodies are the meat, these guys are the potatoes. More than Photoshop savvy or add-ons like flashes and remotes—heck, more than *the camera body*

itself—good glass is often the biggest difference between a crisp shot and a blurry one. And their costs reflect that.

The good news is that lenses can last forever. Even despite a lack of autofocus or image stabilization, many old-school photographers still use their film SLR lenses on digital bodies. That's because lenses don't age the way camera technology does—a good lens can be locked onto anybody, which is why many photographers who start off with Canon (like I did) wind up sticking with the brand their whole careers, because that's what all their lenses belong to.

If you're unfamiliar with lens focal lengths, a quick and terribly simple rundown: the smaller first number is the widest and farthest-back angle, while the larger number is how far you can zoom. A standard kit lens will be 18-55mm. In a standard lens range, anything less than 18 is considered quite wide, while anything larger than 300 is a strong zoom. There are bigger extremes on both ends.

To use myself as an example, my primary lens is a 24-105mm. I like it for flexibility, and though it's not as wide as I like to get when shooting landscapes, it covers a good range in a relatively tight package. If I carry a second lens for a landscape/cityscape shoot, it would be to complement my 24-105—I recently picked up a Canon EF 16-35, which is a great wide-angle lens and yields even better results in landscapes and cityscapes, but useless for zooms.

There are five general focal length ranges for lenses, each with a different purpose:

We'll start with **ultra-wide-angle** lenses. Usually between 12-18mm, these are ideal for vast, expansive landscape shots, but they give a different sense than you'd think—because of the amount of peripheral vision they offer, they're the closest thing cameras can come to replicating human eyesight. That means that when we see an ultra-wide shot, we feel immersed in it. Get close to objects rather than

standing far away. Many photojournalists use ultra-wide to get up close to subjects and snap a portrait while still grabbing a lot of surrounding context: they'll stretch out nearby objects and distort depth of field, but without technically distorting the image—unlike a fisheye lens, which offers an equally wide angle but with unrealistic curvature.

The next tier of lens would be the **wide-angle** lens, with a 20-35mm range. These will come a good deal cheaper than ultra-wide on average, so if you're a beginner, you're more likely to be grabbing one of these. But they are still terrific for all-encompassing landscape shots. They're often light, small and heavy-duty enough to endure trekking a mountain to grab a heavenly sunset snapshot. Whether you're standing far away for a wide vantage point or want to play with foreground/background sizes, you'll definitely need a wide-angle in your gear bag.

In the 50mm range, there are a large number of fixed **prime lenses** that usually stick around 50mm and offer a much faster aperture. The f-stops on these lenses can go as low down as 0.5, though for even just $100 Canon sells a prime lens with an f-stop of 1.8 that's great for portraits and close-ups.

If you want a bit more versatility in a single lens, **amid-range zoom** is a good bet. With an average of 24-70mm reach and often pretty fast apertures of around f/2.4, they encompass the breadth of standard fast prime lenses (like 50mm fixed lenses) and offer something a bit more extensive than the standard 18-55mm kit lens. A lot of photographers say to skip the mid-range zoom, since it's neither a strong zoom nor a strong wide-angle, but when you're shooting landscapes and don't want to lug around a lot of gear, simplifying can be great for saving time, not to mention space and weight in your bag.

If you plan on shooting subjects from far away—across cliffs or from building tops—you'll likely want **telephoto zoom** lens, something between 70-300mm. I rarely carry one around because I usually

am looking for wide angles in landscapes—which this is definitely not. Nevertheless, they're incredibly useful for grabbing faraway details like flowers, people or statues that I wouldn't normally see otherwise.

Lastly, there's the titanic **super telephoto** lenses, 400-800mm. These guys are hefty, expensive beasts that will certainly double (if not triple) the cost of your entire pre-existing camera gear. I tried a friend's once for fun but haven't needed one ever since; they're common for sports or wildlife photographers who want to grab quick close ups from the sidelines. Otherwise, the fact that 400mm is its widest setting makes them incredibly restrictive for landscape photography, and frankly a burden to lug around and switch on and off your camera body.

Lens Verdict

There are more options, also: when I travel, I like to keep my kit light and use a single 18-200mm lens to encompass everything from a wide-angle to a decent zoom. I'll sometimes bring a 50mm prime lens along for the ride if I want a balance with a focus on depth of field, but if I need a single lens, I'd prefer variety to lugging around more weight.

The problem with the 18-200 solution is that, when you pack so much depth of glass into a single lens, you're bound to find some distortion at either extreme (the 18 and the 200mm). This is worse in, say, an 18-300 lens, but it's still a big enough problem—combined with the fact that it's less than ideal in low light and colors come out a bit murky sometimes. But, for me, when I'm traveling often and can't deal with the bulk, the pros outweigh the cons—literally.

Otherwise, there is, again, no "right answer" to the lens question—as long as you carry two or three that complement each other, you'll be fine. One ultra-wide, one mid-range and one telephoto would be ideal. If you're a hobbyist, the sky's the limit.

Tripods

Tripods are pretty much essential for most types of photography, including portraiture, landscapes, and cities at night and posed scenes.

With all these varieties of photography, tripods are needed because so much of it depends on stillness. This is especially true at night, when long exposures become more than attractive—they become pretty well necessary to see anything at all.

Further, if you plan on exploring the world of HDR photography you will need the camera to remain absolutely still through bracketed shot sequences.

When shooting with a tripod, you want to capitalize on speed where you can. If it takes you a long time setting up your equipment for each photograph, you're going to find yourself taking a lot less shots. You're going to want a tripod that's quick to adjust and get situated.

The biggest considerations are weight and sturdiness. For my Canon 5D—one of the heaviest cameras on the market—I use a heavy-duty tripod from Really Right Stuff and an attached L-plate, which is admittedly on the more expensive end of the spectrum, and not necessary for every photographer. I shoot enough landscapes and cityscapes that I felt my career justified the cost.

I didn't start out with that setup, of course. I used to have a smaller travel tripod, the flimsy kind that folded up into a backpack easily. This worked fine to prop up my camera in normal weather conditions. The best factor was that it fit really neatly into my luggage, which is great to avoid checking luggage on planes.

The problem was that, because it was lighter, it was quite vulnerable to motion from the wind and my long-exposure images came out blurry unless the weather cooperated. It also took a lot more time to set up

because there were five incremental leg extensions instead of three, which is standard for heavier-duty tripods.

Filter Your World

There's a great deal of debate surrounding whether filters are necessary on every lens in your kit. Some will argue that if you're spending $1,000 on a lens, you ought to protect it—I use a B+W 77mm UV filter to protect mine, which causes little discernible difference in the end result, but simply protects my lenses from getting scratched.

Others will claim that a cheap filter ("cheap" is often classified as "less than $100") will create unwanted flare or mug up the image quality. This is certainly true of some brands: it's best to do research and test out a few filters before purchasing one, if it's just for protection and not any added effect. (UV filters are common for this.)

That said, if you want a filter with some usefulness, there are loads to shop for to benefit your landscape shots. Like I mentioned earlier, neutral density (ND) filters are great for long exposures during daylight hours, because they darken the image enough to balance out the light let in by leaving your shutter open for seconds at a time, allowing you to shoot foggy, dreamlike waterfalls straight out of Narnia.

Another practical filter is a polarizer. These tend to take the harsh edge off bright whites and bring color out of gray areas, but most importantly, they cut reflections out of water and glass—an effect that's technically possible to replicate in Photoshop after the fact, but difficult enough that it's worthwhile just to buy the filter.

A lot of landscape photographers also like to shoot with a graduated density filter. This is similar to neutral density, except instead of covering the entire lens, it creates a gradual effect from neutral density near to the top to normal colorization at the bottom. It's purely for bright landscapes—ideal for when the sky is a harsh brightness, but

you don't want to darken the bottom half of the frame along with it.

Common HDR techniques can solve this problem in post-production, but it's usually visible to the naked eye that photos are retouched like that (a subject we'll discuss in greater length in chapter 5); a graduated density filter creates a subtler, more natural image. And besides, like every instance of in-camera-versus-post-production, using a filter often takes way less time.

Final Thoughts

While this list is by no means exhaustive, I hope it offered you some insight into the possibilities of a standard gear set. You won't need to buy everything I mentioned—but it's good to know what exists, because something might pique your interest.

The important thing, above all, is to take good quality shots. Never be dissuaded by the fact that you don't have something you think you need to snap a good image. Try anyway, and experiment away—sometimes, you never know… You might just impress yourself.

CHAPTER 9

PHOTOS AS ART - SEE THE WORLD THROUGH A PHOTOGRAPHER'S LENS

As a photographer, your eye is your lens. After you start exploring the world with a camera, you'll find that you automatically begin to see things differently: you'll notice more the composition of architecture, or appreciate how the sun is glistening through the trees at the right angle. You might see the framing of the moon through your window as a photographic opportunity.

Photography teaches us to appreciate our world—visually at first, but also emotionally—in a whole new way.

But not everyone is born with a photographer's eye. You should definitely check out more photographs online in your spare time by browsing Flickr or 500px, but you can also hone your eye just by knowing what makes a photograph aesthetically pleasing.

Compose Yourself

Structure is a key component of photography, and art in general. There are a few ways to define structure—generally, it can be defined in terms of color, shape and contrast between lights and textures.

One of the reasons keeping the basics of photo structure in mind matters is so that, if you do something right, you can keep doing it. There's nothing worse than an aspiring photographer who takes a shot and loves it, but can't articulate why.

You may hear the word "**composition**" a lot when it comes to art. Composition refers, simply, to where things are in the image—whether

a head is touching the far end of the frame or in the center of the photograph is a matter of composition.

When composing an image, look for what's striking—a bold color, or a figure sticking out.

Rule Your Thirds

All photographers should be aware of what the rule of thirds is, so they can use it if they choose. This rule should be viewed as totally optional, but it is a valuable guide to creating visually pleasing and well-balanced images.

One of the oldest concepts in art—not just photography, but all of art itself—is the rule of thirds. If you're unfamiliar with this rule, it simply states that images look nice when they're divided into threes. Imagine a tic-tac-toe grid overlaying your image: three lines up and down, three downs left-to-right.

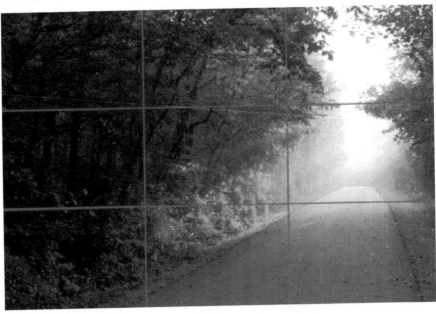

Consider almost any shot of a mountain: sky fills the top third, the mountain range is in the middle, and there's a good deal of grass or a valley beneath that. Three big areas, three sections of the frame.

The "third position" is the intersection of this tic-tac-toe board. There are four thirds positions, making up the points of the rectangle in the middle of the frame.

If you're working with any particular subject, try popping it into the thirds position instead of the middle. Symmetry works sometimes, but shooting off-center gives off a feeling of movement and fluidity. If you're focusing on a tree in the woods, rather than framing it centrally, try placing it in the left or right third of the frame. You'll notice the difference: rather than looking static and square, your shot will look more appealing.

Why cut them into thirds?

Images divided into third exude an inexplicably peaceful vibe. They feel comforting to look at, like they're naturally meant to be that way.

Some believe the rule of thirds is a spinoff from a famous mathematical sequence known as the Golden Mean, Divine Ratio or Fibonacci sequence. Not to get too technical, the sequence (developed in 1200 A.D. by Leonardo Fibonacci) means that you start with 0 and 1, and add the last two numbers in the sequence together. Like this:

0, 1, 1, 2, 3, 5, 8...

(Explanation: 0+1 = 1, 1+1 = 2, 1+2 = 3, 2+3=5, 3+5=8...)

...And so forth. But how do we visualize it? The answer comes from the difference between the numbers: the next number in the sequence is roughly 1.618 times the previous one. In mathematics, 1.618 is known as "phi".

Visually, this means the frame is repeatedly divided into 1.618, with arches connecting one corner of a square or rectangle to the next.

This becomes an ongoing spiral, and is a more technical version of the rule of thirds that painters, designers and illustrators have been using for centuries. It creates a natural sense of flow in the direction of the spiral—no matter where on the frame it sits, the focal point will lie on a corner two-thirds across the frame, and if you place your subject there (a mountain, tree, etc.), it's almost guaranteed to give a pleasing feeling to the eye.

This rule doesn't always hold true, of course. The rule of thirds is one of the best (and easiest) to break. Perfect symmetry works nicely as well, and playing with natural borders as frames can lead to really interesting results, too. But it's a good standard rule to keep in mind when out in the field, if you're stumped for an interesting shot and need to get something basic and workable.

Lead Those Lines

Whether you realize it or not, we look for closure in art. Faces are jarring when they're cut off at the forehead; something's off when we see a woman, pictured at the left-hand side of a frame, looking left instead of right. Certain images are more pleasing to the eye than others.

It's our job, as photographers, to know what designs work—what lines and circles automatically soothe our minds—and find them in the real world.

One great way to find closure in ever-expanding landscapes is to look for leading lines. Leading lines are self-explanatory: they lead our eyes, usually from somewhere in the bottom of the frame to somewhere in the top third, or from one side of the frame to another.

Leading lines don't have to be straight, either. They can curve and twist from one corner to another. But there should be a sense of

oppositeness—if you're starting in the bottom-right, you should end in the top-left. You want to take your viewer on a small journey within the photograph.

You should look for lines in nature and manipulate them to indicate a certain emotion or story. If you stumble upon a barren path in the woods, you might want to show as much of the emptiness as possible to show a sense of rustic desolation.

Leading lines are great for a few things:

- Perspective - what looks big, and what looks small?

- Depth - make your canvas look larger with a shallow depth of field

- Conflict - do your lines intersect?

- Grandeur - is someone or something standing at the end of the road?

- Infinity - if your lines circle inside the frame, what visual effect does it create?

You won't always find lines in every shot. You've got to know how to look for them, and how to shoot them.

When you see a tree and want to show its size, get right up next to it and point up. When you want to show a river streaming down from a mountain, try carefully stepping into the river to shoot down along with it. To capture a grandiose valley, get as much of the length as you can—don't just settle for a snippet, but find and angle that shows how it snakes through the mountains.

When you look for leading lines, you can find them everywhere. Even if they're subtle, they can add more depth to your shot than any lens could.

Finding Natural Frames

Just like a photo frame can pull together a printed photograph, a natural frame inside the image itself adds dimension and closure.

When we talk about natural frames, we talk about anything in nature that creates a frame within the shot—vines, branches and trees are typical; rivers or streams sometimes work; if a mountain range splits in the middle, shots can sometimes be framed even between two peaks.

Framing a shot is as easy as finding lines and curves that shoot around your focal point. If you're shooting a mountain and standing next to a tree, take a step back and try to incorporate the tree into the foreground, its trunk and branches creating a partial frame on the sides and top.

Be careful when hunting for natural frames—don't force your image to fit a certain composition when it just isn't there. Choose strong, emphasized lines to your advantage. Try to find lighting and texture differences. Turning a tree with a smattering of branches into a frame for a forest of smattered branches behind it probably won't work as

well as, say, a river cutting through the forest on one side and a fallen log on the other.

If you can find a cave to shoot out from, walk inside and look out. The cave will not only give you a natural frame all its own, but also a new perspective: it turns your camera into a character, an animal or caveman, and invites your viewers to see the world through their eyes.

Finding natural frames can force you to create new perspectives. If you find an especially cohesive set of vines or trees from which to shoot between, it creates an almost mystical environment, like the frame always existed, and was just waiting for someone to peak through it.

Don't be Negative about Negative Space

Negative space is a crucial aspect to photographic composition. Often black or white (but not only in black and white images!), negative space is the space not filled by anything—a clear blue sky, or a blank wall. Often it can be a powerful statement on its own, or simply accentuate the subject of the photo, especially if the subject isn't centered.

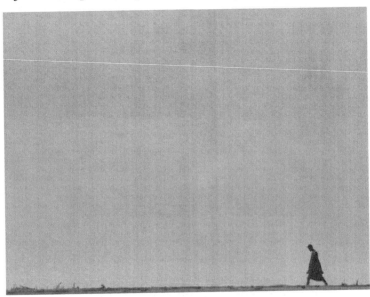

In photography, contrast refers to the starkness of one color or lightness against another. We might see a lot of darkness set up squat against a high-contrast turn, like a lush green park. It makes the park look inviting and warm, against the cold insides of wherever we are.

A shot of a crying girl in a park is one thing. It tells a story, it's a document. But a shot of a crying girl standing against a blank white wall is something else entirely—rather than tell a documentary story, it tells an emotional one.

Chasing the Golden Hour

Of all 24 hours in a day, only two mean anything to photographers: the hour after sunrise, and the hour before sunset. That's when the sun does its magic, casting a heavenly golden glow over the world, making mountains shine and lakes sparkle beautifully.

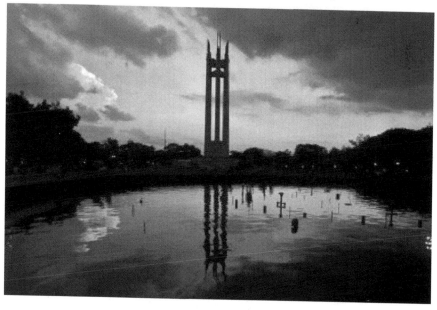

Mind you, the word "hour" there is pretty loose. Depending on the time of year and where in the world you are, the golden hour can last

anywhere from 20 minutes to well over an hour. If clouds are passing by, the whole thing might only be useful for 10 minutes—that's why the elusive moment is so desirable among professional photographers, and why setting up the right shot in advance is so crucial.

The golden hours are pretty much guaranteed to enhance any landscape shot.

They offer a rich natural warmth that's difficult to accurately match in post-production. That said, if you're shooting *into* the sun at this hour—which you might very well be, if you want to capture the purple or orange rays cast over the clouds, or above an ocean—it's a good idea to use exposure bracketing for high dynamic range (HDR), a method of composing multiple exposures in post-production that balance out various conflicting exposures.

Exposure bracketing here is a great idea even if you're not shooting into the sun, because when the golden hour lasts as briefly as it does, you want to guarantee that at least one of your shots turns out great.

If you ever want to shoot directly into the sun, here's a tip: wait for the golden hour. Shooting into the sun can potentially be dangerous to your eyes and damaging to your equipment during regular daylight hours.

That said, using the sun as a backdrop to any landscape or cityscape shot can add loads of drama, great depth of field and sometimes a very cool perspective. If clouds are blocking your gorgeous sunset, use them to your advantage: look for leading lines streaming out from the background. If you're shooting a portrait, rather than using the golden rays as a spotlight, flip your angle and silhouette your subject against the sky.

Depending on your angle, lens and filter, you can also use lens flare to your advantage—something a lot of photographers will add in Photoshop if there isn't any, though it's very tricky, because the wrong

angle can throw off the whole shot. As usual, the best way is to find it naturally.

And then, of course, after the sun has set, what's next? It's common for photographers to keep shooting—they know full well that the photography oasis has passed, but they've got everything set up, and the lighting, while visibly darker (in the evening) or harsher (in the morning), and is still workable.

What's nice about sunset or sunrise photography after the golden hour is that you've got a much more comfortable window to play around with. You don't want to waste a precious second of that golden moment, but after it's gone, who cares? Immediately post-sunset is a great time to experiment with dark, moody shots: the sky is a deep azure but far from black.

Assuming everything else stays constant, you'll need to lengthen your shutter speed to compensate for the lack of light in the evening. The lack of direct sunlight will actually make balancing the light a bit easier, but exposure bracketing is still a good idea if you want to blend images together and work around difficult exposures.

The hour after sunrise is a bit more difficult, because the sunlight will likely be generic and harsh, casting tough shadows downward. It's still workable, though, and better for shadow control than noontime, so go out and find as many cool angles as you can before 11 o'clock if you're out for the whole morning.

Right Time, Right Place

As Woody Allen once said, "80 percent of life is showing up." The same is true of photography: right time, right place.

As a photographer, you've got to train your eyes to watch for good locations, interesting angles and unique shots. When you see one, you won't always have time to set up your heavy tripod and grab the right

lens—you've got to work with what you have, even if it's an iPhone or simple point-and-shoot.

Take a moment to just enjoy the scene and consider the best angle to shoot it—rarely is the best angle where you happen to be standing at that moment. Consider low, high or side angles of any scenario.

When you need to think quickly, it's good to remember the fundamentals of setting up a shot: look for reflections, leading lines and thirds to divide the shot into. But, if you have time, try also breaking those same rules: capture a scene in a unique perspective that people may never have seen before. Landscape photography is tricky, because there's a great sense of "been there, done that." Get creative—you'll have more fun.

CHAPTER 10

HOW TO TELL STORIES USING DSLR PHOTOGRAPHY

There are two key components used to tell the stories in a photograph – angle and framing.

Angle

Angle deals with the position from which you take your photographs. For instance, you can use your DSLR camera to take a shot while standing, lying down on the ground or even climbing to high places. For example, when taking a picture of someone who is short, you can make the person appear balanced among the crowd by taking the photograph from a low angle. In a landscape, using a low angle will show the spaciousness of the sky and cause the land to appear expansive. In order to tell stories using your DSLR camera, the most common angles are high and low.

High Angle

High angle is where you photograph your subject from a high point. You may be up on a tree, on a cliff or on top of a roof. When the shot is taken from a high level, the objects usually appear smaller than their normal size. This conveys a sense of weakness, vulnerability, defeat or lack of confidence of the object. However, a viewer may interpret it differently depending on the context of the scene. For example, when a photographer wants to show poverty levels in an area, they usually use the high angle point.

Low Angle

Low angle involves photographing your subjects from a low level by lying on the ground or kneeling down. The subjects in this case will appear larger than normal. This will show a sense of power, control, confidence or dominance in the subject.

Framing

Framing is usually a method of bringing attention to the specific subject of your image through blocking various other parts using something else in the scene. It is a way of adding interest to an image and accurately portraying the information that you wish to show the viewer. This is done by giving depth to your image, and making your viewers form a perception about the image. It draws the eye of the viewer to a particular scene in the image, brings order while telling a story and adds context. In framing, you manipulate the viewpoint of your image instead of the objects that are inside. Photographers control this manipulation by using techniques such as adjusting the angle, zooming in or out or changing their distance from the subject. By framing images in different ways, a photographer can create a story out of a series of photographs.

Establishing Shot

The establishing shot is a photograph taken from a wide angle. It is used to show the viewer the setting of a story. For instance, when you open a book and the first image is of a big church, you will assume the characters in the story are at a church.

Long shot

After taking an establishing shot, you want to bring the viewers in closer to the characters. A long shot is used to show a full image of the character, from head to toe. When taking a long shot, the character

is usually far away, and the image will contain a large portion of the background. The long shot shows the relationship between the subject and his or her surroundings.

Medium shot

The medium shot shows your character from waist to head. In this shot, the setting is shown to a lesser extent. Your character's body language is conveyed, allowing the viewer a glimpse into his or her personality.

Close up shot

This is a photograph showing the character from shoulder to head. When your character is this close, the viewers are able to connect with him or her at an emotional level. This makes the viewer able to see your characters reaction to the content of the story.

Extreme close up

The extreme close up is used to tell a minor story within the context of a larger one. In this shot, you can choose to show individual parts of the body. Close ups of the mouth, eyes, or hands can be used to show an important message. For instance, if you want to show that your character is afraid, photographing his or her hands shaking will bring out that effect.

Over-the-shoulder shot

The over-the-shoulder shot captures two characters in the same setting who are facing each other. The photograph will cover their shoulders to their heads. It may portray to the viewers that the two characters are in deep conversation. This shot does not show the emotions of your characters, allowing the viewers to make their own interpretation of what is happening.

CHAPTER 11

TRICKS OF THE TRADE (EXPOSURE, LENS, HDR)

There are so many tricks to the trade that it would be impossible to mention them all here. Instead, we're going to go through some of the more interesting tricks that you may never have thought to try otherwise.

The goal here isn't to make you a master of every domain, but rather to expose you to every trick available to digital photographers today, and see what sticks. You won't be great at everything—in fact, some styles you may even resent, like shaped bokeh or HDR photography, which many purists scoff at modern photographers' over-reliance on.

But that's fine. Don't listen to them. I want you to shoot the kinds of shots that you think look best—no matter what the others say. And the only way to do that is by experimenting like crazy.

Other than that, you should know that these are all techniques that are nearly impossible to replicate in post-production applications like Photoshop. These are all in-camera techniques that many photographers choose to specialize in. If you're ready to take the plunge, then let's get started:

Long Exposure

The first and most common trick is long exposure. For this, you'll need a tripod, and sometimes even a neutral density (ND) filter, depending on what you're shooting.

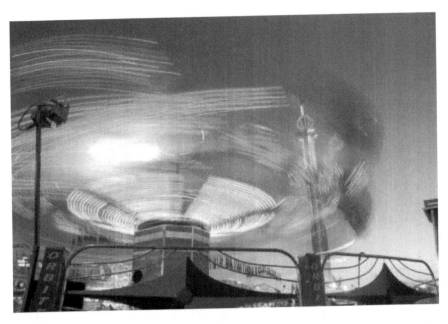

Long exposure shots are exactly what they sound like—they involve leaving the shutter open for an extended period of time, usually a few seconds at least. For that reason, a tripod is imperative for long exposure shots, because any movement at all can cause the camera to shake and your image to be blurry. You should also use the self-timer or a remote cable release to avoid pushing the button on the camera, which causes additional shakiness. As a final touch, turn on the mirror lock-up option in your menu to avoid the minor shakiness that simply opening the mirror invites.

Long exposure shots are most common against movement: think of cars streamlining down a highway, crowds of people in a mall disappearing into ghostly blurs, or the water from waterfalls blurring together into a milky smooth flow.

By capturing the entire time it takes to move from one end of your frame to another, your still camera is capturing a single frame of

movement, but also capturing all the movement. So if you leave your shutter open for three seconds, and have someone walk across the frame for three seconds, the shot will capture all of that person's walk, but nothing will be in focus.

In other words, it uses motion blur to your artistic advantage.

Long exposure shots are typical at night, because the long exposure doubles as a way to brighten up a dark scenario. If you're shooting cityscapes, you can make bright city lights explode in a glorious array across skyscrapers and highways by lengthening your exposure time, and the secondary effect is that any movement will be blurred. Buildings don't move, so you'll have them in crisp focus, but any people and cars will turn into softly blurred images that create a sense of hectic movement.

If you're shooting a city during the day and want to capture that same hectic movement, you'll need to crank down the ISO and probably add a neutral density filter, which will darken your image and allow for longer exposures in brighter conditions.

An ND filter is also useful for waterfalls, which are rarely shot at night because of the lack of artificial lighting. So, because you'll almost always be shooting during the day, you'll need something to darken daylight to allow for your long exposure. This is how professional photographers capture those smooth flowing rivers and streams, too.

Light Painting

If you want to take long exposures to the next level, you can try out light painting—a very niche photography style that involves a lot of preparation, dedication and trial and error.

Light painting is literally painting with light. You'll need a flashlight, or some LED light source, and a totally dark scenario with your camera on a tripod. Set it on an extremely long exposure—something like 30 seconds or even a minute or two, depending on how much light you have available and how elaborate you want your painting to be.

Because there's no light except for your flashlight, you can use your flashlight as a paintbrush and create brushstrokes across the frame. When you review the shot, you'll see you've created shapes in much the same way as a painter created a work of art.

People use light painting in a number of ways: some illuminate objects in particular ways to create a rustic, old-fashioned look; others illuminate models standing still to create alien-like subjects; others spend minutes in front of the lens creating elaborate abstract combinations of circles and lines.

Light painting isn't for everyone—in fact, it's so niche that most light painting photographers specialize in that and don't bother with traditional landscape photography or portraits, because they prefer to explore this new variation on the medium. If you have patience and a flashlight, you might find it worth your while.

High-Dynamic Range (HDR)

High-dynamic range photography, shortened to HDR, is the latest trend in digital photography, overcoming problems of exposure balance when you're shooting something with a lot of darkness and light that needs balancing.

The concept is that you take three shots with different exposures. (You can use exposure bracketing for this, or grab three exposures manually depending on what you want to correctly expose with each.) You can then combine the three photos into one photo using a program like Photomatix. Between the three exposures, you should be able to correctly expose the entire shot—this creates a balanced image, rather than one that is awkwardly very dark and very light in different spots.

HDR photography is chic these days because it creates hyper-realistic images, making lights shine brilliantly against light-blue night skies and keeping everything in crisp focus. It often looks unnatural. Some people like this; others detest it, calling it hokey and overdone. But it often results in vibrant, striking images with powerful color palettes and truly innovative atmospheres.

The thing is, HDR photography didn't begin like this. It began as a solution to the common problem of needing multiple exposures in a single shot. Shooting a portrait of skiers on a snowy mountain, for instance, you'll be faced with the problem of the snow being extremely bright, the skiers' faces being darkened by shadows, and the mountains lit up by the sky being somewhat correctly exposed. By shooting it in HDR, it would allow for three exposures—one with the skiers' faces correctly exposed (but everything else super-bright), one with the snow properly exposed (but the faces and mountains in complete shadow) and one with the mountain background looking good (but everything in front of it looking a bit dim). By combining these three, you're allowing for them all to be in focus, well lit and looking sharp—and it won't look unnatural, either.

One problem with HDR photography is that, as you might have guessed from that example, it tends to lose depth of field. HDR-affected images might look shallow, and it's nearly impossible to do with a shallow depth of field, as in a traditional portrait scenario. But this is primarily a landscape technique, because otherwise, foreground lighting issues could be solved by adding external flashes and spot lighting on places

that need brightening up—and in landscape or cityscape photography, you'll likely be shooting with a deep depth of field anyway, to make sure everything is in focus.

Regardless, HDR is a common technique that's worth playing around with. You'll need a tripod, and the composition of each shot must be completely identical for the shots to match up. Don't be afraid to overdo the hyper-realism at first and see if that look works for you. Maybe you'll agree with the purists, maybe you'll appreciate the bright colors and crazy lights. Either way, the important thing is that you expose yourself to it.

Fisheye Lens

This technique isn't difficult to pull off—it just requires a single lens purchase that will probably cost a few hundred dollars.

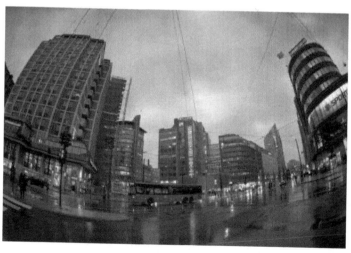

A fisheye lens is a super wide angle lens that doesn't try to balance the distortion that comes with a circular lens. What makes most ultra-wide angle lenses expensive is that they need to allow in a wide breadth of the frame without compromising the image at all. Fisheye lenses embrace that natural distortion, and photographers run with it.

Fisheye lenses are fun to play around with, especially if you're going for a surreal look. They can capture an entire room in a circular view, or interpret a beach as an orb-like landscape with a totally unrealistic but very distinct viewpoint, with the ends curving downward into the bottom of the frame.

There isn't much you can do with a fisheye lens beyond the single distorted element, but you can create fascinating close-up portraits while keeping the background in distorted focus, or simply look at landscapes in a whole new way. But be careful: fisheye lenses can make images look kind of tacky if overused, so try to find images that look truly cool and unique with them applied.

Forced Perspective

Perspective is a very fun thing to play around with. You know how things look bigger closer up, and smaller farther away? Play with that! You might recall vacation shots wherein tourists are doing things like "holding up" the Leaning Tower of Pisa, or holding their hand out in a pinching shape and "squishing" someone behind them.

Well, the same can apply for more artistic photos, too. Using perspective can create innovative portraits, but also play with nature in fun ways—you can make a flower look enormous in the foreground to balance out a mountain behind it, or frame a tree behind a transparent bottle, so it looks like the tree is captured inside. Always look for little details that can give you freedom to play around with reality.

Wide angle lenses are important here, because telephotos tend to compress images so their depth of field seems smaller. You should also use a higher f-stop to create as deep a depth of field as you can—otherwise, the background will be blurry, which will work against the effect you want. You can also use the Aperture Priority mode, which will lock in your aperture to make sure it doesn't change (if you're otherwise shooting on automatic).

Shaped bokeh

Shaped bokeh is a less common technique, more often done as a special effect for very specific purpose than by professional photographers.

Bokeh, as a reminder, is the word for the blurred-out hexagons or circles that appear automatically when you focus on a subject in the foreground. The mark of a good portrait lens is a soft, pleasing bokeh, rather than a harsh and pixelated one.

Well, there's a third option: shaped bokeh.

It's a bit of a DIY project, and you'll need a good portrait lens— something prime, or at least a lens that reaches large apertures of under f/1.8. Then, all you need to do is cut a filter for your lens out of construction paper with a particular shape in the middle and place it on the lens securely, using another piece of construction paper in the shape of a lens hood.

Set your aperture large and choose a subject to shoot—then fire away, and you'll notice that your background becomes cutely shaped like whatever image you cut out in your pseudo filter.

Go Further

There's no end to the tricks you can accomplish with your camera— we haven't even covered half of it. And if you engage in Photoshop and post-processing, you can learn a whole lot more.

The key to all these tricks isn't to teach you "the best" way to shoot photography, but to prove that you should never accept your own limitations. You can exceed them. Try something nobody's seen before. Combine these tricks, or experiment in different ways. No one's going to judge you just for trying something new—if nobody ever did, none of these styles would exist in the first place.

HOW TO USE SPECIALIZED ALTERNATIVES IN PHOTOGRAPHY

Wide angle lens

A wide angle lens allows the photographer to capture an entire scene. It has a large depth of field and a small focal length to capture the details of the entire scene. Most photographers use a wide angle lens for landscape, architectural or interior photography when they are unable to use distance to increase perspective. It also creates a difference in size between the foreground and the background. Objects in the foreground stand out strikingly while those in the background have a subdued appearance. It is important to frame your image carefully when using the wide angle lenses to avoid capturing distracting features in the scene.

Telephoto lens

A telephoto lens has a powerful zoom and is used to take photographs of objects at great distances. It can also make the distance between two objects appear compressed. This is useful when you want to emphasize multiple objects. Telephoto lenses are often used in wildlife photography as it can be very difficult to get close to animals like lions and rhinoceros. It has a narrow angle of view. Therefore, you need to be selective about what you want to appear within the frame of the photograph. This will create a focused and simply composed shot.

Fish–eye lens

The fish-eye lens is designed to shoot extreme wide angles of 180 degrees which makes them useful for "backup" cameras in automobiles

or for security cameras. When applied to photography, however, they can create very interesting images. They have a large depth of field that allows your photographs to appear well focused throughout. Scenes with intriguing and foreground and background can largely benefit from the use of a fish-eye lens. Photographers use these lenses while shooting extremely wide landscapes or the sky, when getting a close up of building interiors or crowds and in extreme sports like surfing and skateboarding. It also enables one to take photographs with strong contrast and saturation in shaded areas.

Tilt and Shift

Tilt enables rotation of lens relative to the image, and shift allows for movement of the lens parallel to the image. The ability to move your camera lens up, down or sideways allows you to be in control of your images' perspectives. When you tilt the lens, the focus point moves and the amount of information shown in the scene can be decreased or increased. The shift movement is used to avoid the convergence of vertical lines in your image, and it is most often used for outdoor photography.

CHAPTER 13

HOW TO ACHIEVE THE BEST EFFECT USING FILTERS

Filters refer to equipment that is attached to either the front or the back of the camera lens. Their main purpose is to enhance the effects of the camera lens. Filters also act as a protector to the lens from dirt, scratches and damage. They are also used to change the exposure of the camera, to increase contrast in images, to minimize reflections from non-metallic surfaces or to capture light outside of the visible spectrum such as ultra-violet or infrared. Filters can create a more natural look to photographs. You should choose a filter based on the type of photography you are indulging in, the type of your DSLR camera lens you are using and your available budget.

Polarizing Filter

A polarizing filter is very useful in enhancing the color and contrast of your photographs. This filter works by selecting the rays of light that are allowed to reach your camera lens. It will minimize reflections in water and give the sky a deeper blue color. A polarizing filter requires a longer exposure time for your photographs.

There are two types of polarizing filters, linear and circular. The circular polarizer is the most common and is best for your DSLR camera. It is made up of a special glass which, when turned towards light source, reduces the reflections in the image. It is fitted to the end of the lens and can be rotated when needed for adjustment. These filters are mostly used when shooting cities or buildings on clear, bright, sunny days. The filter can allow you to take photographs of objects beneath the surface of water or behind glass. The best effect depends on your shooting angle. A 35 degree angle is best around bodies of water, and a 90 degree angle is best for the skies.

Neutral Density Filter

Neutral density filters allow for more freedom and creativity when using DSLR cameras. A neutral density filter reduces the amount of light that enters the camera sensor and makes the light more uniform by placing a translucent piece of glass in front of your camera lens. It is one of the simplest filters to use. When using this filter, the image contrast and sharpness will be maintained. While getting a neutral density filter is important, you need to understand that you cannot use this filter on its own but you will need to adjust your camera settings accordingly. For instance, when using a neutral density filter and you maintain the same shutter speed, you will have to use a larger aperture to get the same exposure. Similarly, if you maintain the aperture and use a neutral density filter, you will need to use a slower shutter speed in order to get the same exposure. These filters are nice because they do not alter the color of your image. However, in some cases where the

filter is stronger, the image might appear gray or dark. Therefore, it is important to select a quality filter to get the best effect. They are best used when taking photographs of water or landscape. This is because the neutral density filter gives a smooth look when shooting water scenery and makes the water movement appear blurred. This effect is also used in viewing the moon because the neutral density filter will increase the contrast and cut down the moon's brightness so one can view the surface clearly.

UV Filters

As their name suggests, these filters eliminate ultra violet rays without affecting the exposure of your aperture, shutter speed or ISO. The sun's rays can be a large problem, especially when taking landscape shots. If you use a UV filter, it will erase the blue cast that is created in photographs when it is very sunny...

CHAPTER 14

MAKING YOUR PHOTOGRAPHS INTO COMPOSITIONS

There are two words that will dominate this section. The first is **composition**, and the second is **rules**. If you read through the instructions shown below, you will find that neither is that complex and that you can employ these rules to really get the most out of your photographic composition. This is vital because it's what people see when they look at one of your images. Think of a photograph as a picture rather than a point and click opportunity. Photographs are used for all manner of things and yours could be good enough to display on walls or to use for greetings cards if the composition is well thought out.

When a photographer asked you to be *composed* so that the picture will look good, what he is asking of you is to be organized in front of the camera and ready for the shot. Why? It's simple-- our eyes tend to reject chaotic things, and we lean toward liking things that look properly organized and well put together. This principle also applies to taking photographs, the pictures, too, have to be composed. As stated previously, photography is in effect artwork and therefore the composure of the photograph will determine how people perceive it to look. Thus you need to adhere to the rules of composition to get the best photographs that you can. It isn't just about looking through the viewfinder and pressing the button.

The good news: there are certain rules you can abide by so that your photos will be composed.

The rule of thirds

This rule is simple; most cameras have features that will show you a grid. The grid is composed of four intersecting lines that will form 9 equal squares. You shouldn't always place your subject in the middle portion, in fact, it will look better if the subject (especially a person) is placed to the left or right of center, dividing the image into thirds. If your camera does not have the grid feature, just estimate using your eyes. Try different placements, as this will show you what this does to the composition. For example, something that is in the foreground can be put to the left of the grid, making room for background to add a lot of character to the image. However, if using the camera for portraiture, centralizing the image is a good idea. It's not always necessary. It depends upon what your idea is for the composition. Take a look at these images and you will see how portraits can use the rule of thirds as well as centralized focus.

Both kinds of images work because one give full focus to the face and the other gives a dramatic backdrop, making the image more powerful but using the law of thirds. This can be applied to any kind of image, whether this is portraiture or not.

The rule of odds

Another simple rule is to make your subjects in odd numbers. For example, if you want to capture drops of water, it is best if there are

three drops instead of two. The principle behind is based on the concept that the human eyes are drawn into the middle of the odd number.

This can be useful for nature photographs where the emphasis is not on a particular feature but the image as a whole. Three rain droplets on the flowers, spread out over the picture will invite the viewer to see the whole picture, rather than focusing on one

particular drop or looking between two drops. This may sound a little strange, but try to imagine what you create when you use two of something in an image. People tend to look between them, rather than seeing the whole picture. Thus, the rule of odds makes sense.

Image: Creative commons

The above image shows the rule of odds. One central drop but it has been cleverly aided by the spread of the water, so that the eye is drawn to the whole picture, rather than the single drop.

Rule of Space

The rule of space (or the rule of leaving space) sounds so simple-- you just have to leave a certain space devoid of subject, much better if it is blank and there is nothing significant to be seen there. The rule of space will give the illusion of movement, and it will also give the viewer a breathing space, especially if the photo is intense.

Fill it up - Contradicting the previous rule, filling it up means that you have to maximize the space, leaving nothing that is "senseless." You have to be careful though, filling the space is different from crowding the frame. Often times, filling the space is done by cropping out the distracting background-- the end result is a frame full of your intended subject. The image of a child at the end of the last chapter is a perfect example of filling the frame. This means there are no superfluous details and what you get is a perfect representation of what you wanted to portray.

Determine the color

Honestly, there is no strict rule when it comes to color, but the fact still remains that ruining this aspect, a photo can be also be ruined. The rules regarding colors will depend on a lot of things like the emotion you would like to promote and what you want to focus on. For example, if you want to deliver calm and tranquil feeling, blue and other cool colors are good, red light invoke alertness, and sudden bright glares can emphasize your focal point all the more. Never believe that white is white as there are so many shades determined by the lighting used when taking the image. This applies to the intensity of all colors as well. Remember that light comes into the picture as well because the brightness of the light will determine the intensity of the color within an image. If all else fails, you can use Photoshop layers to improve the color of your image, but it's far better to get it right first time. Atmosphere is created by capturing the image when the colors are just right and this may mean waiting a while before taking the photograph. A hill at sunset may be much more startling to the eye than it is in the noon day sunshine.

Balance

Balance is making sure that chaos and boredom is prevented, the frame should not be too crowded, nor should it be too empty. One good technique in accomplishing balance is by finding the perfect

angle. So, don't be contented with the usual straight shots, you can tilt the camera to find something better.

This works particularly well, for example, by coming down to a child's height when taking an image of a child. It gives a whole different viewpoint from if you had taken the picture from a standing up position. Move around to get the best angle. This can be used for pet pictures as well and when you get down to the same level as a cat or dog, you see the image in a much different way. You can add balance to your images by using a small aperture and allowing the background to blur, thus meaning that the eye is drawn to the central or off center subject of the photograph.

Making it simple

Simplification is based on the premise that we have already touched upon before-- the human eyes appreciate less distracting things. Simplifying can be done in two ways, the first one is to fill the frame, and the second is after the photo has been taken, by cropping out unneeded things. You may not be accustomed to using software to manipulate images, but it's extremely simple to do. However, getting the composition right in the first place will give you better quality images, so take your time taking photographs. Choosing your background will help particularly for portraits, where you don't want the viewer to be looking at what's behind the subject, rather than at the subject him/herself.

Compose your photos, take them and then you won't have to crop your photographs and lose any of the clarity. While taking pictures, it is important to ask yourself one important question; will this particular element contribute to the beauty of my photo? If your answer I is no, you might as well leave it out rather than having to crop the image later and lose some of the definition.

The problem with cropping is that you take an image and effectively stretch it by taking out the background and making the new image fit

to the original size. Thus if your quality was already patchy, cropping also diminishes the quality of the image produced. Thus, compose your picture, rather than depending upon software to put the image right. An image is made up of a certain amount of pixels. Think of these as small dots that added together create an image. By cropping, you are getting rid of some of the pixels and therefore, the resulting picture will be grainy and will not be as good in quality as one that was not cropped.

The use of leading lines -

These are known for more than just their usefulness in emphasizing the foreground. Leading lines also serve the purpose of directing the viewer to the field you want him or her to look at. Leading lines can take any form: straight, curved, diagonal-- as long as the landing line offers direction, any line (or pattern) can be used.

Image: Creative Commons

Look at the leading lines in this image, pulling the viewer toward the focal point of the picture. Had the lines been used to one side, it would not have been so effective in giving the viewer a focal point. Your eyes are drawn toward the center of the image, but you are also slightly distracted in a good way to seeing the whole picture because of the line of the horizon and the color change to the sky, added to which the clouds give more energy to the picture.

Capturing texture -

The problem with photos sometimes is this. They seem to be simply images caught for the sake of it, rather than photographs to be proud of. Most of us want them to come alive, to have depth or even to have a three dimensional look about them but fail because the lack of texture makes the image look flat. One good way of giving pictures some dimension is by capturing the texture of the subject. Doing so will make your viewer 'experience' what it feels like if they touch it.

In the last image, for example, look at the unique textures that were combined to make a whole – the wood of the pier, the blue and white fluffiness of the sky and the ripples of the water made a whole image. Imagine this image showing a blue sky with no clouds, a distant shot of the pier where you couldn't really see the wood texture and the sea represented by a uniform turquoise color. Amateurs take pictures such as this without thinking of incorporating the texture. This is where focus is so vital to creating really good images.

The best technique in capturing the texture, of course, is by doing a close up shot that allows the detail to be shown.

Symmetry -

Before you note it, symmetry is not the same as balance. Symmetry happens when the things that can be found on the left side, can also be found on the right. Most photographers use this rule to break free from

the rule of thirds, which is good, especially if the symmetry is located on areas where it does not usually occur. Symmetry with leading lines also looks appealing to the eyes.

An image that uses symmetry can indeed give perfect balance to the subject being photographed. To a certain extent the picture of the pier has perfect symmetry because it has an equal amount of sea at each side of the pier. Symmetry is often used in wedding group photographs and you will notice that the photographer has a habit of arrange people by height so that the smallest are at the outside and the tallest in the middle. There's a reason for this. He is applying the rule of symmetry to the image because that's what people expect in a group photo. If you were to have a wedding group with no attention paid to this rule, it would look strange.

Although this picture is not intended as a perfect example, what it does show is the rule of symmetry. See how the photographer has arranged the group? A bridesmaid has been placed on either side of the

couple to balance the color aspect and to provide symmetry and the men at the outside of the picture have been arranged so that the tallest is central and the shorter are at the edges. This picture doesn't have perfect symmetry but it does demonstrate it adequately.

Background -

As they say, one of the most common mistakes in photography is missing out on the background. You might become too enthralled with your subject and find that you overlook the beauty of those objects directly behind it. Photographers also make the mistake of getting backgrounds that detract from the main subject. Perhaps in a touristic location, the picture of friends is spoiled by tourists walking by at the wrong moment.

Of course, that's not to say that you should always include a specific type of background, but the point being made here is to see if the background is worth including in the photograph. You may have noticed with wedding photographs, for example, that the photographer moves the bride and groom to different areas for more atmospheric photographs. He uses the arch of the church door for a typical group photograph, while the bride and groom photographs may be softer and more sentimental when taken against a background of nature.

The whole point is that the background can often add to the atmosphere and make a photograph look rather special. If, for example, you want to photograph the facial expressions of a child. If you were to photograph this with a busy background, much of the impact of the photo is lost. Using a background which is more neutral and which may even be faded out by clever use of your lens, you would then draw the emphasis to the features that you felt important enough to photograph.

Image: PublicDomain

In the image shown above, look what the eye leads you to. This is a very clever photograph because it uses white to obliterate the background and give it softness. By doing this, the photographer was able to place the emphasis on the face of the baby. A small touch which was added which gives away that it's a boy is the blue symbol on the front of his outfit which is not strong enough in color to take away any of the emphasis intended. It's a magnificent example of how background makes such a difference to the overall picture.

Point of view

Is almost the same with angle (finding the perfect shot), only now it will seem like you are directing a film. For example, taking a photo of someone while you're in higher place will make it look like he/ she is small; the viewer will feel big looking at the photo. Taking the photo of anything while bending down low can make the subject look

bigger, and the viewer feel smaller. The point of view is important to photography. If, for example, you want to take a photograph of a cat, many people make the mistake of taking it from a standing position and wonder why the photo is disappointing. Let us show you two examples that will demonstrate the difference between a snapshot, taken without thought, and an image that used point of view. You may have seen many of the first style of photograph when your friends have sent you images of their cat. It shows a cat in motion but it lacks the ability to convince the viewer that the cat is doing anything other than simply walking.

Image: Creative Commons Attribution: Soniastock

Now look at how this kind of image was tackled by someone who realized the significance of point of view. Point of view just means the point from which you viewed the image.

Image: Creative Commons

Notice the detail on the second image. Your eye is drawn toward the cat's facial features and a clever touch was added of including the single flower on the left hand side of the picture that is also focused upon. Black and white imagery added texture to the image but it is the point of view that made the photograph so good. The photographer had the camera at a level that could catch the cat's face perfectly. This makes the picture absolutely stunning, even though the photographer chose to use black and white. The contrasts are superb.

Of course, your photo will not always have leading lines, in that case, you will just have to make the subject more prominent using some other ways, like turning it into a focal point, or filling up the frame with it. It's a very clever detail to be able to use point of view and then to add the other rules such as the rule of thirds. The last image shows how effective this is, since the background is almost obscured and the cat is sitting to the right of the image, but still remains the main feature.

What many photographers, or would-be photographers achieve when they take pictures of animals is mediocre pictures. If a photograph isn't something that's good enough to hang on the wall as art, chances are that it will sit in a box of photos somewhere and only surface again by chance. If the photograph incorporates artistic merit and photographic skill, it's much more likely to become a favorite photograph and find a starring place either as wall art or as a photograph that gets its own frame. Your images should always be thought of as artwork, rather than just a photograph because if you start thinking in this manner, you will start to see the images differently through the viewfinder. It is then that you will discover just how important it is that you choose the right position, the right stance and the right composition.

CHAPTER 15

WHAT TYPE OF PHOTOGRAPHER ARE YOU?

No single photographer enjoys every form the art. When you're starting out, you might enjoy taking portraits, landscapes, trick shots and spots photos—but with time, you will probably find yourself falling more towards one style of photography than another. Or you might go through phases—so long as you decide to dive into a single style and really perfect it, rather than casting a wide net and staying there.

By now, I hope you've tried out a few of the tricks and photo styles we've discussed. That way, you can really appreciate what each one takes, and what kind of images you enjoy seeing and trying out.

In this quick chapter, I'm going to review the types of photography that might strike your fancy. Again, it's good to try them all—but try to specialize in a niche or two, and really appreciate and understand what it takes to excel in that, at least before you tackle another style altogether.

Portrait Photography

Portrait photographers need one thing most photographers never will: communication skills. Portrait photographers need to learn how to break the ice, talk to their subjects and get them to ease up and reveal their inner selves.

One of the greatest living portrait photographers, an artist who goes only by "Platon", has captured the humanity of dozens of celebrities and politicians, including actors like Christopher Walken and Will

Smith, and politicians such as every United States president of the last several years.

Platon's technique is sophisticated—he acts quickly, and tried to approach each of his incredibly busy subjects with a quick icebreaker. I once watched a YouTube video of him describing a photo shoot of Russian president Vladimir Putin (a shot which later became an infamous icon via Tim Magazine), wherein he explained that he asked the Russian strongman what his favorite Beatles song was. Putin, whom Platon knew was a fan of the band, relaxed and replied: "Ahhh, 'Yesterday'." This gave Platon an in. He could break through the bodyguards and political business to reach someone on a human level. That's critical.

Landscape Photography

It's the job of a great landscape photographer to capture the emotional essence of a place and show it to others. Their goal is to inspire people to travel and better appreciate the world in which we all live by showing everyone sites that they may never have known even existed.

That's the difference between a vacation photo and a landscape one: vacation snaps are mementos; landscape shots are invitations.

As a landscape photographer, you need to be aware of two basic concepts: what to look for, and how to shoot it. Not all great landscapes make great photo—oftentimes, valleys that might seem dazzlingly wide in person will make boring shots. You need to search for strong focal points and interesting details, and apply the classic rules of photographic art—natural frames, the rule of thirds—if you want to create beautiful works out of the world.

Consider mountain photography. At its best, mountain photography reminds us of how small we are. To capture a mountain is to capture its grandeur, its awesome magnitude against the minute details

that surround it. We love looking at mountains, because they're so impossible: they're difficult to live on, difficult to summit and often difficult just to reach. If photography is the art of capturing what the eye cannot, mountains are the art's ideal subjects.

And yet, unfortunately for camera fanatics, the difficulty of mountains translates into photography, as well. Photographers have to not just hike the thing (difficult already), but also lug all that extra gear, and suffer the added pressure of being in the right place at the right time. They've got to be aware of lighting conditions, and be prepared to find a whole new angle of something that's existed for millennia. The best mountain photographers are avid hikers and patient artists, ready to trek up remote trails and bushwhack through the wild to capture something few humans have ever seen before.

Street Photography

Street photographers deal with candid shots—unplanned, spontaneous moments found on public streets. Street photos are best when they're unfiltered, raw and human.

Sometimes street photos are planned, but often they're not. You're meant to just head out with a camera and subtly take shots of people being themselves. This is a fundamentally dangerous art—especially in certain parts of the world, where photographing strangers is considered extremely rude, or at the very least might get you punched in the face and your camera stolen.

But for those who can pull it off, street photography is a classic form of photojournalism, or documentary photography, that captures a time and place better than any other form of the art.

Eugene At get, a Parisian active around the turn of the 20th century, was arguably the first street photographer to gain public fame. His works show Paris the way it truly was—vibrant, lively and full of color (even

though his shots were black and white, of course). In America in the 1950s, this trend caught on with the hipster Beat movement, led by Robert Frank in an attempt to discover the real America by wandering its city streets, alongside contemporaries in different artistic fields such as Allen Ginsberg (in poetry) and Jack Kerouac (in literature).

Today, street photography is common, and arguably the cheapest form of photography. It's easy to snap a photo of people on the street—no flash, blur is fine—but it's much harder to transform this reality into artistic, productive forms of art.

Sport Photography

This very lucrative niche is great work if you can get it—but you need to invest heavily and have a lot of experience, first.

Athletes are great to photograph in action because they often strike terrific poses. Who doesn't love seeing LeBron James leaping through the air, his eyes wild and mouth screaming open as he reaches for the net above? Athletes are expressive, momentous and committed—ideal subjects for photography.

The problem is, they're also not paying attention to you. Needless to say, athletes move extremely quickly, and in order to capture a great moment, you'll absolutely need a good lens. Unlike landscape or travel photography, for which you can get away with an iPhone when absolutely necessary and still come away with a potentially decent shot, sports photos are strictly professionals.

If you're interested in trying it out, head to local high school and university games with a pack of gear. You'll need a strong camera and solid telephoto lens. Ask a coach or someone in charge if nobody minds that you're taking photos, because you love watching the sport and want to practice your shots. Often, the students will be so excited to see themselves afterward that they'll all look forward to

the experience, and you might even be able to sell a few shots to the parents.

Cityscape Photography

Cityscape photography is, in many ways, a natural counterpart to landscape photography. The same general rules apply: consider skyscrapers as mountains, roads as rivers and glistening lamplights as a lower version of starlight.

The best cityscape photographers understand that cities are symbols. Cities symbolize the triumph of what men and women can create when they work together, an accumulation of electricity, steelwork and design. But good city photographers also understand that cities are kind of terrifying: they're absorptive monsters that consume us in traffic gridlocks. We see a photo of a downtown skyline, spot a small yellow square of light coming from an apartment, and realize how small we are in these densely packed urban areas.

Good cityscape photography makes the viewer feel both things: awe and terror. It should make them feel exhilarated at the endless possibilities tucked into every corner of downtown Tokyo, but also petrified at the enormity of Shanghai's systemic twisting roads. From an aerial view we can spot all the boats in Toronto's harbor, the landmarks of New York's skyline, and the Signature Rivers coursing through London, Seoul and Paris.

When we see cities, we see everything.

The biggest difference is that cities change at night. A mountain is a mountain any time of day, but by night, a building transforms into a blaze of lights to challenge the stars, roads light up with moving dots of red and yellow, neon lights line the streets in attempts to catch your eye.

Visually, cities come alive at night.

When dealing with all this extra clutter, it's important to remember the fundamentals of photography, which still very much apply. You want to look for interesting angles, not just generic skyline shots. You need to know how to frame buildings of various sizes so the levels (or lack of them) play in your favor. You should understand how to see roads as leading lines and how to use exposure times to manipulate the movement of foot and car traffic.

There are a lot more factors to take into account, which can be difficult for first-time photographers. Don't see the human element as a burden, but as an opportunity to create exciting and dynamic images of the unnatural environment in which most humans live.

Travel Photography

Ah, travel photography! The broadest category of all! Travel photos encompass everything—cities, landscapes, portraits, street candid's and even sometimes sports.

Good travel photography takes the viewer on a true journey. You're inviting them to tag along on your travel, be it to the deserts of Mali, the pristine beaches of Bali or a small mountain tribe in northern Laos. Every shot you take has to be reflective of where you are—a sense of place is important above all else.

With that in mind, even great shots that don't give a sense of place can't rightly be considered *travel* photos. A beach shot is nice, but unless you show me a local native or some cultural icon in the shot, I could be looking at a beach in Israel or California. Cityscapes are fine, but cityscapes including ancient temples situated right downtown or magnificent global architectural icons actually make me realize what places look like.

You want to make your audience say, "I had no idea that's what Paris looked like."

As a travel photographer, you'll need to be diversely trained in every aspect of photography, because you never know what might pop up. When I travel, personally, I most enjoy taking street photos through food markets, because I feel they give the strongest sense of place and culture—we see people, food and architecture all at once. But you'll never want to come away from a city with only one type of shot. It's necessary to include a variety of shots, which is why diversity—in both skill and imagination—is key.

Wedding Photography

And now for something completely different: wedding photography isn't what you think it is, because what you think it is probably what *everyone* thinks it is.

A great wedding photographer treats weddings as art, not just moments to be accurately captured. A good wedding photographer can turn the most important day in someone's life into something beautiful they could never have imagined.

I'm talking about striking dramatic poses between the bride and groom (look up Moshe Zusman or Eigirdas Scinskas for ideas about what I mean), macros of placement details with beautiful bokeh behind them, and candid shots that don't just capture facial expressions, but combine those expressions with gorgeous framing and lighting in something more artistic than a simple memento.

Anyone can take photos at a wedding, and anyone with an SLR can charge money for it. But if you want to be a great wedding photographer, you need to have a game plan—a strategy for what you're shooting and when—and appreciate that your eye needs to be honed professionally even while people are ignoring you and going about their own lives.

Sure, you can pop up and say, "Excuse me, do you mind striking a pose?" But candid shots are so much better with weddings—and for that, you need to be a professional, high-quality fly on the wall.

Wedding photographers need to be constantly alert and move swiftly, because these events are full-blown parties that you'll have trouble stopping just for a perfect shot. You need to do a tremendous amount of pre-planning and be prepared for several nonstop hours of capturing as many moments as you can in an artistic way.

For engagement photos and wedding portraits, you need all the same people skills as portrait photographers, but with the added stress of this being a generally high-anxiety environment where your subjects may have no idea what they're doing, and are too distracted by the thought of lifelong commitment to commit five seconds to a genuine pose.

Wedding photographers need to be in control. Set the tone, and your subjects will relax and follow suit.

Photojournalism

If your background overlaps at all with journalism, or you have a craving to know all about current events, or you love rushing into danger when others are running away from it—you might find luck as one of the fewer and fewer working photojournalists in the world.

Photojournalism will always be in demand, because people need to see what's going on in the world. But it's an extremely demanding form of photography—possibly the most demanding, because it requires a quick mind, brave attitude and still all the knowledge of what makes an image sing.

Photojournalists have to understand a wide array of photography. They're closest in kin to spontaneous street shooters, but will also spend a good deal of time posing subjects like politicians and artists.

Transit is also a necessary evil of photojournalism that most aspiring enthusiasts don't consider—how do you get from one side of the city to the other in half an hour? Owning a car is critical, but being able to bike or hop in a taxi on a whim is also often a key component.

The fact is, photojournalists for newspapers are catch-all, who need to excel at having both communication, technical and artistic skills. You need to be able to think creatively and grab a shot for a story even when there's no obvious shot, or show up to a neighborhood looking for an image, and be able to turn whatever's there into something worthy of print. There's little time for Photoshop, and you'll have editors breathing down your neck every step of the way.

But for the adrenaline junkies out there, there's no better job.

Nature Photography

Love animals? Have patience? Nature photography could be your calling—the refuge of every quiet animal enthusiast on the planet.

There tend to be more amateur photographers in the nature field than in most other areas of photography, because nature photography hobbyists tend to be passionate about the cause. They love sitting in one spot waiting for a wild mammal, bird or insect to appear for the briefest of moments. And when you capture that image, the results can be totally unique and mesmerizing.

Nature photography is more than wildlife photography, of course. Hiking out to hunt for rare flowers or bird watching are both relatively quiet, meditative outlets for photographic sense.

Nature photographers will likely leave the ultra-wide lenses at home. Extreme telephotos are the lens of choice, those enormous camouflage super-zooms that require extra luggage and cost thousands but take quiet, faraway shots like nothing else.

To turn nature into art takes more skill than patience, though both are key components of this highly specialized form of photography. It's also difficult to make it lucrative—aside from the few lucky buggers who sell to National Geographic, this will likely remain a side hobby for enthusiasts alone.

Fashion Photography

On the other side of the spectrum, fashion photography—arguably the more lucrative sibling of portrait photography—is a guaranteed way to stay in business. Fashion photography is up there as one of the most common types of professional photography, simply because of the size of the media game—clothes retailers, cosmetics companies and, well, pretty much anyone selling anything these days relies on fashion photographers to make their product look sexy.

Fashion photography is different from portrait photography because of the heightened emphasis on style. Every type of photographer needs creativity as a cornerstone of their art, but fashion photographers are more reliant on their ability to blend human imagery with abstract art—to contort bodies into shapes, and use makeup and inventive clothes to create unnatural images that bend our minds in innovative ways.

Of course, traditional fashion photography exists also—but it is simultaneously a realm of great experimentation, and is ideal for creative minds to find each other and work together.

Best of all, it's relatively easy to create your own portfolio. I know several budding photographers who've gotten great exposure and taken excellent shots of amateur models simply by striking up a pro bono deal—both the models and the photographers need shots to fill their portfolios, so why not work together?

Commercial Photography

For everything else in the world that needs photographing, there are commercial photographers—arguably the most ubiquitous, successful and standard form of working photos out there.

Commercial photographers shoot anything that needs shooting—products, mostly, like cars, clothes, furniture or groceries. If there's a photo of something in a newsletter, magazine or newspaper, a commercial photographer took it.

The upside to commercial photography is that it pays the bills, but most commercial shooters tend to have side hobbies as well—something less lucrative, like nature or landscape photography. Commercial photography is not a great outlet for creative juices.

Much of commercial photography relies on understanding artificial lighting and having a strong sense of comfort around a photo studio. Setting up accent lights and back flashes is critical to creating the most appealing situation to see your subject.

And the last bit of good news? Once you break into the industry, it's easy to keep making contacts and getting jobs.

Specific Trick Photography

There's no shortage of trick photo styles—light painting and forced perspective come to mind as particular specialties that hobbyists engage in.

If you want to engage in trick photography professionally, the market definitely exists. You'll likely be spending a lot of time in Photoshop (this is true of every photographer, but it's especially true of light painters and HDR lovers), but you might find yourself feeling constrained by reality.

Trick photographers see our physical world as just the first stepping stone in a much larger game.

Anything I've missed? Go For It

There are more types of photographers, of course. There are sub-specialists for every genre I've just mentioned. (Kids' portraits, concert shots, food specialists, pet photos—if someone needs a photo, someone needs a professional.) If you can find a niche and you love to shoot it, market yourself hard—soon, word will spread, and you'll find yourself keeping busy.

Like I mentioned above, few photographers stick to one single style. Likely every photographer will dabble in commercial work to pay the bills, enjoy landscape shots while on vacation and try to win some National Geographic contests with candid's or nature shots. Rarely does one style occupy a photographer's entire life.

But do yourself a favor and try your hand at everything. Throw a few darts at the board and see what sticks. Explore your possibilities, and you may find that you develop an interest in a subject you never realized you cared about before

CHAPTER 16

IMPROVING YOUR NATURE AND LANDSCAPE PHOTOS

If you are a beginner, you will have a penchant to taking photos of nature and landscapes, sometimes with human subjects, but sometimes without. In this section, we will discuss the most effective tips when it comes to taking pictures of nature and landscape. You need to remember that a missed opportunity may be something you will regret. Thus, carry your camera with you, so that when nature gives you that perfect shot, you are ready to grab it. Nature does that. It shocks, it amazes, but most of all it gives a photographer a chance to show the world that moment as it happened, pulling all the elements of nature into the image, together with the color, ambiance and beauty.

Making use of a tripod - Using a tripod is very beneficial, especially if your shutter speed is slower. Some photos become blurry because your hands suddenly jerk in the middle of taking the photo. The best way to ensure that your camera is still is to use a tripod. This is also useful for taking speed shots because if the tripod allows a pivot of the camera you can follow the movement of animals and still keep the camera posed perfectly to take the shot without wobble. A tripod also helps you to capture something predictable. Thus, if you line up your camera, you may be waiting for that opportune moment to take the best photo, but when it happens, your camera is at the ready. This is particularly relevant for sunsets, as the sky can change from moment to moment, but you will have already decided which point of view your photograph will be taken from. It's just a case of waiting until nature obliges you with the perfect shot.

It's worthwhile investing in a small tripod as well as a full height one, because this is so useful when you are out on location. It helps you to be able to have instant stability for your camera and since the small tripods can easily be carried in your camera bag, these really are a must for getting great photos.

Creating a perfect focal point

In interior design, a focal point is something that your eyes cannot let go of. Yes, your view may stray from time to time, but they will return to the focal point. If you were to walk into a room, the first object that catches your attention is indeed the focal point. This could be a fireplace, a painting on a wall or something that the homeowner has used as their chosen focal point to draw the eye of the beholder toward it.

It's the same with photography. Choosing and capturing a focal point in your nature and landscape photo will prevent boredom from a viewing point. A focal point can be anything-- just make sure that you choose something that captures the hearts of those who look at the images once they are produced. For example, the cat photograph in the last chapter, in black and white, has a focal point. The cat's face, his features and expression were all caught perfectly. In the baby photograph, the focal point was the face of the baby.

To give you a better idea on how to make your focal points clearer, follow these guidelines:

Contrasting shapes and color

If the shape and color of your focal point stands out, it's much better and much more likely to be recognized as a focal point. Look at this picture of a mallard. You will see that the colors of the mallard are particularly noticeable. The reason for this is that the photographer has used a background that didn't detract from the stunning nature of the color of the duck. The duck thus creates a superb focal point.

By choosing a background that was fairly bland, he drew attention to the plumage of the duck that is indeed the focal point of the image.

Image: Creative Commons

You can clearly see what a stunning effect the plumage has on the image, since this features as the overall focal point of the picture, although the blue adds atmosphere to the picture as well.

The bigger the better - While it is impossible to find a big focal point, huge ones help emphasize them more. But then again, remember that the way you are placing the focal point also plays a role. Positioning will be discussed in the later chapter about rules in photography, though you can see how the size of the duck plays a part in how amazing it looks. Similarly a close up image of the baby's face made it a real focal point in the baby photo in the last chapter.

Blurring the background

This can be very effective if your focal point it not moving, but the background is mobile. What you will need to do is set your shutter speed to a slower setting. In the case of the picture of the mallard, the water behind the mallard was moving, though the photographer obviously didn't want this to detract from the focal point of the image and thus blurred it by changing the shutter speed.

Let foregrounds strike

The foreground is the part of the scenery that is closest to the viewer. In other words, this is closest to you while you are taking the photo, and closest to your audience when they see the picture. In the image of a cat, look how being in the foreground of the picture made it startlingly attractive. You will need to learn to get up close and personal with subjects and in the case of nature, this may mean using longer lenses that still retain the quality of the image being taken.

To better help you in including the foreground in your landscape photography, follow these simple tips which have been written from experience and which are used on an ongoing basis by photographers all over the world to improve the way that their pictures appear to the viewing public:

Look for patterns

If the foreground has a pattern, especially lines that are very prominent, make use of them. The lines and the patterns usually draw the attention and give the viewer some sort of direction. This was used in the image of the pier and worked very well.

Lower the camera position by bending down - What most photographers do to put emphasis on their foreground is to stoop down low. This means that the ground itself is being brought into the visual field. If you are using a tripod, you might as well lower down the

height. This was demonstrated in the cat image, because by getting down to the level of the cat, the picture became a lot more focused on the cat at his own level. You can use this for scenery because it helps you to gain extra perspective.

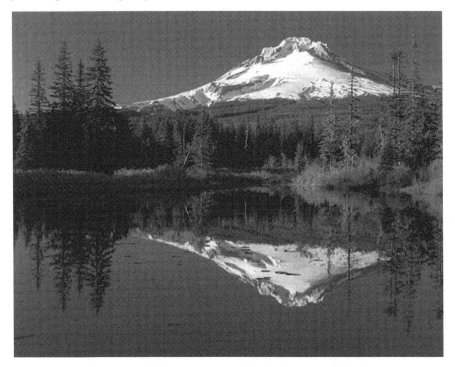

Look at the foreground of the image above. To get a photo like this, the photographer would have had to sit lower to capture the reflection of the mountain in the water. Had he decided to take the image straight, without having composed the image, he would have lost the opportunity to get all of the detail that has been captured in the image. Thus foreground helps considerably in composition.

Check and recheck the quality of the image in the viewfinder before pressing the shutter. Sometimes people guess when taking photographs. They don't use the LCD because light is stopping them from seeing clearly the composition of the photograph. If you cannot see the image

through the LCD screen, try to shade it so that you can get a better idea of what the image encompasses. This is so important. Every time you don't bother, you miss an important opportunity.

Things That Detract From The Quality Of The Image

Often people take photographs without stepping from one side to the other to find the best pose or angle. You see tourists often snapping away without giving great thought to composition. If you look on Google Images or similar websites, what you see is a whole host of photographs taken by people of the same thing, but the quality of some will be much greater than others. Some will have distracting objects in the background, some will even have the composition so badly organized that the photograph is really not up to par. Yet others will take scenery shots too close and lose the potential of showing the glory of the area that has been photographed. For example, taking a photograph of waterfalls, some photographers are so enthused about the waterfall that they forget about all the aspects around the waterfall that may add to the quality of the picture. By the time they have finished, the waterfall could be anywhere, but by composing the picture, they actually show it as being somewhere very memorable.

The photographer in this case remembered to include foreground but the monotony of the color scheme makes the photograph look more mediocre than it could have been. Look at a superb example of a photograph of a waterfall and see how color and texture were used to make the photograph more interesting. The image below captures it all. You have color, texture, composition and depth. That's what photography is all about. Although it is possible to Photoshop the first image, even doing that wouldn't give the image the depth because it's lost the beauty of composition and has simply turned out like an "average" point and click image. However, the image below is composed of so many rich elements that it can be seen as a superior photograph.

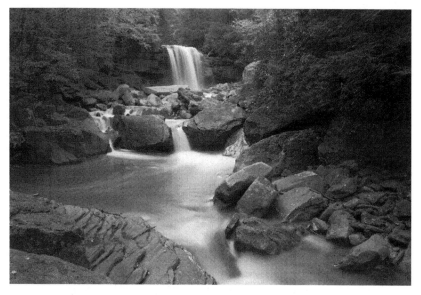

Image: Creative commons attribution: Forestland

Instead of the colors showing monotones, this extremely clever picture shows a richness of detail second to none. Look at the water. It looks almost like melted silver. Look at the tones of the rocks and the use of the rule of thirds, splitting the image into three sections that combine to make a whole.

Don't rush it

Most people, once they see what seems to be a perfect scene, start rushing clicking with abandon. The thing is, you can never rush art. What you must do is take time-- practice until seeing the perfect point of view becomes second nature to you. Remember, if it's not good enough to hang on your walls as wall art, it isn't the best that you can do. Even with cheap cameras, great pictures are indeed possible.

Professional photographers take lots of frames. That way they get to pick the best of the bunch. Rather than depending upon editing the image using software, they take pictures from various angles and use different points of view so that they eventually have a photograph that is the best that it can be. There are some startling examples of professional photography in magazines such as National Geographic. It's unlikely that these were first time takes. Thus, take several images from several angles and you open yourself up to more choice when it comes to deciding upon which images you wish to share with your friends and family or even use in photographic competitions. You may also get a stunning image that you didn't expect and learn a better technique of taking pictures at the same time, even though the angle you used was an experimental one.

Horizons

What you use for your horizon on your photograph is really your own choice. The standard horizons that most people choose are skylines where the earth meets the sky or where the sea meets the sky but these don't have to be the only possibilities are far as horizons are concerned. The top of a roof can make a good horizon if photographing something of architectural value.

A hedge or a break in the scenery can also be used as a horizon. Try different positions and imagine the paintings that grace the art galleries, since these are scenery pictures that use different elements to bring

the whole image together. Since photography is art, the photographer needs to begin to see that their photographs are only as good as their artistic ideas when taking the image. The horizon of an infinity pool can be extremely stunning in a photograph because one doesn't expect it. It adds startling detail and gives the impression that the earth drops away to nothing, thus making this horizon a very artistic one against the right background.

The time of the day

The time of the day plays a very big role when it comes to the issue of natural lighting. Daylight hours when the sun shines the brightest give a good opportunity to the photographer to create a picture which is clear, although different times of day can be used for their atmospheric value. Dusk or dawns give great opportunities to be artistic and to use the colors of nature at their best.

The opportunities of getting accustomed to using natural light early in the morning gives the photographer a chance to experience their skill of judgment in what setting they put their camera into for such images. If you are a little afraid of your camera, then the "automatic" settings will give you an idea of what can be achieved, but also try to be more adventurous and use manual settings as well because this extra experience will help your overall photographic ability.

Don't be afraid of the weather

Real photos do not come from convenience. It is true that it is easier to capture moments when the ground is dry and the clouds are few, but sometimes, gloomy weather can give you the photos that you desire. You may not have a choice in a moment when you need photographs, so get accustomed to using the weather to your advantage. For example, snow may mean that unless you adjust your camera settings, you may find that your images are over-exposed because of the brightness of the snow. Similarly, you may have to adjust the camera to account

things such as mist in the morning, rain showers or rainbows.

No matter what the weather is, the opportunity for good quality photos should not be diminished by what weather is prevailing. Look at this image taken on a misty morning and you will see that the amazing quality that was produced does credit to the photographer who must have exercised great patience to have achieved such a great shot.

Image: Public Domain

Look at the atmosphere that is created in the image. The mist allows different layers to be created among the trees. This won't have been taken on a warm day, or in good weather. In fact, you can feel the coolness of the atmosphere from the image.

What they have created is a wonderful picture either at sunset or sunrise that shows a level of hope in the sun hiding behind silver lines

cloud formations, above the mists that cloak the earth. That's very poetic but it's also proof that an image can be taken even in adverse conditions and can still pull of the "stunning" photograph image that people want to achieve.

CHAPTER 17

IMPROVING YOUR PORTRAIT PHOTOGRAPHY

Portrait photography is popular with most amateur photographers and since the popularity of "selfless" it's no wonder that this form of photography is used so frequently by people wanting to show off their talents at self-expression. However, for the photographer who simply wants to produce quality images, it's important to start thinking of yourself as a photographer, rather than as a friend taking a picture. The sooner you do, the sooner you will realize the significance of all of the elements that go into taking great portraits of people. There are some very famous portrait photographers and what these photographers have accomplished is the ability to combine the natural looks of their subjects, coupled with great photography props and techniques.

Child Portraits

If you want to capture the face of a child, for example, look at school photographs. Although these are not the best examples of capturing character, they do have a professional edge to them, in that they concentrate on the head and shoulders of the child, thus making them the standard for portraiture. However, you are unlikely to get a child to sit still long enough to capture the formality caught by school photographers and you probably wouldn't want to. Instead, the moments that you want to capture of children are that magical moment of discovery or growth that goes by almost unnoticed but that mean such a great deal to parents. These, captured in an image, are extremely valuable portraits.

Look at the wonder in the eyes of this child. Caught at a stage where the child still has her milk teeth, the portrait captures the personality of

the child and is a great example of portrait photography.

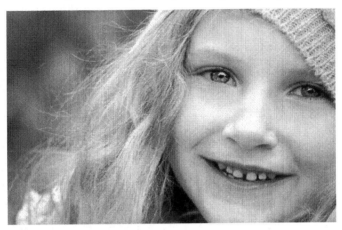

Image: Public domain

The photograph taken in natural lighting captures even the sparkle in the child's eye. This was taken close up at a moment's notice and is a spontaneous example of what a photographer can achieve with a little thought, the right lens and a cooperative child. The focus on the subject is perfect. Taken with a Nikon camera at an aperture of f5.3, the photographer used a shutter speed of 1/320s and the detail caught by the camera is stunning.

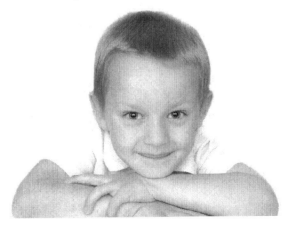

Image: Public Domain

As a total contrast to the last picture, this is an indoor shot that uses white as a natural background. Just as in the baby photograph in an earlier chapter, what this does is bring out focus on the face of the child and the mischievous eyes.

This method can be used with a close up lens but better results will be obtained using a tripod and lighting that helps to blank out the background. The kind of lighting used in studios is typically lights on a stand with a metal umbrella to reflect the light rather than point it directly at the image itself.

This picture was also taken with a Nikon camera and although you may not own one, you can try pictures such as this using different setting to see which give you the best results.

Image: Public domain

Portraiture which is not in traditional style where the model sits is very popular in this day and age and look how the movement was captured in this image without any detraction from the quality, the focus and the overall detail. The texture of the water is clearly shown, as is the movement. Taken with a Nikon camera, the shutter speed used was 1/250 s and the focal length was 62.00 mm with an aperture of f/13.0 and an ISO of 300.

If you want to get photographs such as this that involve movement, you will need to adjust your camera for a speed shot and hold it very firmly in your hands. In a beach setting it's unlikely that a tripod was used, but what you can do to give the camera more stability is to have it attached to a strap for extra security and set it up in advance. Then, when the picture presents itself, you don't have to worry about dropping the camera, you will have already focused in on the distance and only need very fine tuning and can snap the picture easily. Even if you miss an opportunity such as caught in the image, the chances are that another will present itself very soon.

Traditional portraits of older people

Traditional portraits of family members are usually pretty starchy in nature, but they don't have to be. With the right lens, the correct lens adjustment and the right light, even the harshest of realities can be softened so that the portrait is complimentary and the image not too harsh. Remember everyone gets older, but not everybody wants to see their image showing the reality of old age. You have the technology to soften the blow and if you use it, chances are that even more family members and friends will be pleased that you helped to take portraits that matter to them.

Image: Public Domain

Although this image is not of an elderly person who has anything to worry about as far as wrinkles are concerned, it does help me to explain to you how different angles help in portrait photography and how different areas of the face can be shown in a great light. Most people have a favorite side. This is because it gives a much more favorable viewpoint. As a photographer, you need to find out which side of a face looks the best. This professional photograph shows how light can be used to bounce off the face, giving it a lighter look. The head held high helps to give the subject a particularly elegant look. The makeup is perfect, though stunning results can be obtained even if this is not the case.

Sometimes the natural pose of a woman rather than a forced one gives a great opportunity for a portrait. Don't be nervous about trying different poses. You will get a very nice one if you do try from either side, try with the head tilted, try with the face looking directly at the

camera but be aware that if flash is used, you will get red eyes. To avoid this, the subject will need to look slightly away from the flash. It is the reflection of the flash in the eyes that causes redness and although this can be fixed, it's far better to get used to using a photographic technique that avoids it in the first place.

For portraits of young people, putting the image to one side against a plain background gives great impact to the image. Head and shoulder images no longer have to be boring and if you experiment with them, you will find that people will love your photos more than the snapshots which are taken without thought.

CHAPTER 18

NATURE PHOTOGRAPHY

There will be times when nature shows itself as so stunningly beautiful that you are tempted to take that camera out and get the best picture that you can. It's wise to carry your camera with you for this reason. Nature photographs are always going to be popular and when you are walking in a forest, you may just encounter wild deer grazing or something equally as magic and not have your camera ready for the shot.

Preparing your camera in advance

If you are taking a walk on the wild side, then make sure that you have a telephoto lens on the camera. If you have a smaller compact camera, having a zoom will benefit you enormously. You may just want to capture the moment that the humming bird came so close you could almost reach out and touch it, so if you choose a mid-range zoom or a telephoto, you cover yourself for most opportunities. The last thing that you need to be thinking of is changing the lens or getting the camera out of its bag.

Thus make sure that you have a strap so that you can have your camera ready to take photographs. Start to think like a photographer, rather than keeping the camera tucked away. That break that you take to set up your camera could lose you the shot. Make sure that your image setting on the camera is set to the best quality and that you have a spare memory card in case you run out of room on the card in the camera. There's really no excuse these days because memory cards are so small, you can pop one into your pocket and easily switch over the card when the need arises.

If your camera depends upon charge, make sure it's fully charged before you go out to take nature photographs. Imagine seeing this deer and then finding that the battery is flat in your camera!

In the above photograph, look how relaxed the baby deer is. The reason for this is that the camera was far enough away not to disturb the deer's afternoon rest. Most people manage to get far away shots of deer that you can only just see if you squint to look at the photograph, but if you carry your gear with you on your excursions, you have the equipment to be able to produce an image of this quality. If you are going to produce nature pictures, it's absolutely vital that you learn to use a light meter especially in circumstances such as those when this picture was taken. Perfect light settings on the camera can mean amazing images are possible.

Taking pictures of insects

If you want to make a stunning impact with insect photographs, you need to learn to sit and be patient. Imagine seeing dragonflies up close

and even having them sitting on your hand. This really is possible in an environment that is close to a river, though if you want to catch great photographs of insects, you need to sit for a long time and wait for the perfect opportunity. Set up your tripod so that there is no movement or shake when you do take that image, and relax until the perfect opportunity arises. Using a small tripod gets you up close and personal with nature and means that you can choose where to prop the tripod and get the ideal shot. Take your time. Compose your picture and don't just settle for a photograph with no composition.

On a digital camera, often even cheap ones, there is the ability to switch the mode so that you have it on a natural setting. This may be symbolized by a flower in the menus. This usually means that the image will be biased toward natural color. Then look to see if you have the possibility of using macro. If you have, this is ideal for insects, but you have to move the camera to the ideal position so that the insect is perfectly in focus. If you do use macro, make sure your exposure time is short because it's unlikely that you can use the tripod

in circumstances such as this, so you may need to use a short exposure so that there is no shake when the image is produced.

This macro image of a ladybug shows so much detail that you can see the fluff on the leaf, the shine of the ladybug's shell and it's almost as if he donned his best coat just for the photograph. Composition rules again and is the most important element when taking natural shots. You may think it's enough to have a picture of a ladybug, but then look at the image above and you will see that you could have an amazing picture of a ladybug if you wait for it to isolate itself so that it takes center stage.

Birds

Birds are amazing. Caught in flight, or shown strutting their stuff like the mallard in the earlier chapter, birds really do give you an

opportunity to shine at photography. Remember, the golden rule and it really can't be repeated enough. Composition is everything. Sure, you can crop a badly composed image, but if you get it right when you take it, you don't compromise the quality of the image.

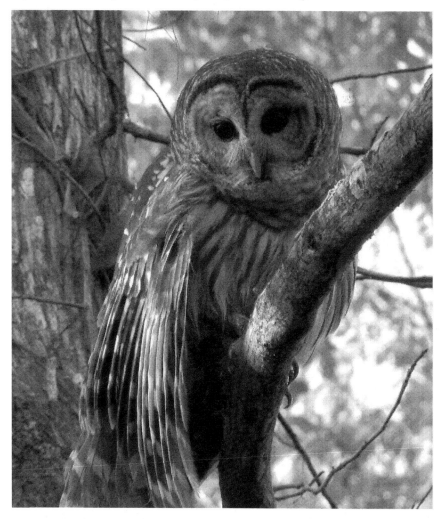

The composition on this image is perfect. The balance of color and light allows all the detail of the bird to be seen and the textures of the feathers contrast against the texture of the wood, the greenery adding

light to the image. If you want to take bird pictures, expect to take many before you get one as good as this, but persevere because if you do, it pays off big time as the image you will take will be stunning.

The bird in flight in the next image is absolutely breathtaking. The photographer went to a great deal of trouble to get this much detail, but it's possible if you have a great lens and the patience to wait for the right moment. This was taken with a Canon, using an ISO of 800, aperture of f5.6 and a shutter speed of 1,4000s and the result is wonderful.

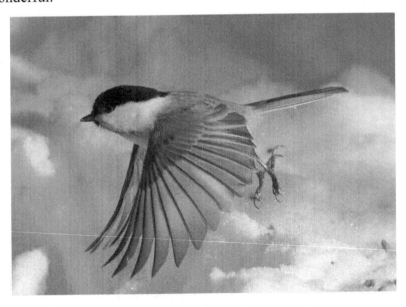

If you don't have the equipment to take this quality of image, try a bird sanctuary where you are given more opportunity and can snap to your heart's content until you get that one wonderful picture.

Big game pictures

Even if you are never likely to go on a safari, you have the opportunity to take pictures of big game or larger animals in a zoo environment. Too many people take mediocre pictures because they don't know the

capability of their cameras. If you have all the preparation done that was mentioned at the top of this chapter, you can get some great shots, even if the animals are in cages. There are two approaches to taking pictures of animals in zoos. One is to show the animal without all the zoo background because this gives a really great opportunity to show off the species in a wonderful photograph.

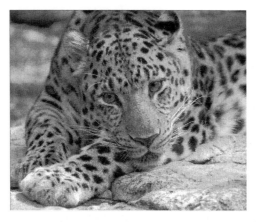

The other way to look at it is to use the cage purposely to show how the animal feels locked away.

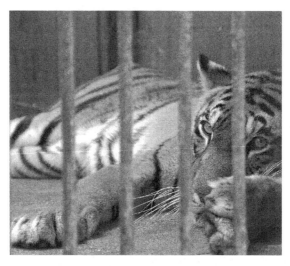

This image makes quite a statement and has great composition as well. You can take wildlife images even in a rural environment that are impressive. You just need to take your time and move from one angle to another until you find that perfect composition. It's vital to use your light meter, to try from different angles and to capture the moment if you believe that the image you see on the LCD screen is as good as it gets.

Nature offers so many opportunities and this chapter gives you an idea of how you can get great pictures just by taking your time. Remember:

Composition – Light – Angle – Aperture – Make sure of camera settings – Shoot!

You can get some great shots of animals if you take your time. In a wooded environment, the use of a hide will help you and many nature parts have these so that the public can watch the animals close up. Use these opportunities to get the best shots that you can and you will be proud to share those images with friends.

Look at the average photos on Facebook and make your images better than average. That's what true photography is all about and when you discover it, you will never look back. In fact, you will find that you tend to look at other people's photographs more critically as well which is good, because it means that you are recognizing what it takes to create a really wonderful photograph.

As you continue your photographic experience, you will also learn to adapt to the circumstances that present themselves when you take an image. That's important because weather conditions, light and all the different variations that may spoil your image will be elements that you are more aware of.

CHAPTER 19

FLOWERS AND WILD PLANTS

Contrast and Detail

Your own yard offers you a wealth of opportunity. Did you grow a rose that is beautiful? Did you see a plant you have never seen before? What you need to understand is that moments in nature may only present themselves momentarily. Don't be complacent about photos or wish that you had your camera with you when something wonderful happened. If you make sure that your camera is always available, there's no reason why you can't get those images.

Greenery on its own may seem terribly dull, but a splash of color in the foreground can make all the difference in the world.

This image shows you contrast. It's a picture that uses the rule of thirds but it does more than that. It uses contrasts between the type of foliage and it's a simple example of how color adds to the image. One of things that I did in my garden was capture every flower over the course of a year that appeared in the garden. That built up to hundreds because there was no distinction between weeds and plants and the images were pretty amazing. The thing with this kind of image is that you can set your camera to the natural setting and then use the zoom or the macro lens to get the pictures really close up and detailed.

A weed can look absolutely stunning and I take no credit for this image, but it's a good example of what you can capture just by having the camera available at the right time.

There are several ways of tackling a picture such as this. Using the macro and moving the camera back and forth until the image is in perfect focus is a good way. The macro will also mean that the focus will be on the flower itself rather than all the surroundings, as in this

image. Another way is to shoot a picture of the flower against the sky. Expect to get into some difficult positions in the garden to get the picture right as when you do, you will be so pleased with the results.

The focal point of this photograph is the center, but it's a well balance photograph because the darkness of the background, contrasted with the detail of the flower makes the balance and composition good.

In this image, look at the amount of detail. It's extraordinary. The dew drops on the flower and the folds in the petals are so detailed. Using an aperture of f4.5, the photographer chose to use a shutter speed of 1/400s and an ISO of 100. This allowed for more detail to be displayed in the leaves that surround the flower.

It's worthwhile experimenting with your images of plants because it's not enough simply to point and click and it doesn't enhance your album of photographs to do so. With more time taken, you really can create some stunning images of all the plants in your garden or on a walk in the forest.

Natural light in the forest

Every forest has a certain amount of light that comes in between the trees. You need to use this to help your photographs to look stunning. That natural light really helps you to get detail into your pictures.

The light is what creates atmosphere. This picture is optimistic in nature and shows a magical place where trees grow and are nurtured by the sunshine. It's a very pretty picture of a forest but at a different time of day, the picture can be just as worthwhile.

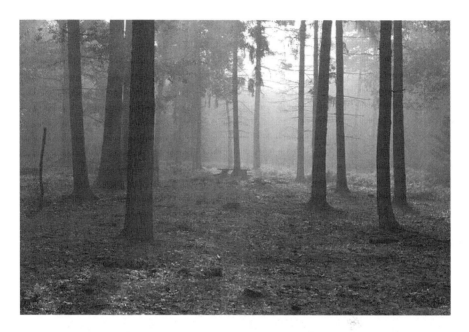

Look at the contrast between this image and the first image and both have special qualities but one uses the morning light and creates an atmosphere which may even be considered as spooky or atmospheric.

Be prepared to wait and to walk a lot because you may find the perfect location but have to wait for the right light in which to take the image. Black and white works well for trees as well but only if there is sufficient detail to merit it. Although people think of black and white images as being terribly dull, nothing is further from the truth these days with the cameras that are available on the market. Black and white is detail orientated and the best photographers will produce black and white images that are stunning.

CHAPTER 20

CHILDREN

You will find that children present a real challenge when it comes to taking photographs because they are so active. A moment in time can present the ideal photo opportunity, but the moment that the child knows that your camera is observing them, they change their pose and the opportunity is gone. Natural photographs of children are so much more endearing and the moments that you do capture can make your family album a whole journey into their childhood and a real heritage to leave them.

If you ever looked through a family album, many of the images of children are posed and although the kids may remember the era when the photos were taken, it's unlikely that the photo will mean as much as it would if the photograph was spontaneous and the children didn't even know that you were taking the photograph.

In the portrait section of this book, you were shown great ways to take portraits and action photographs of children, but the chapter did not offer enough insight into the possibilities that are open to you when taking photos of kids.

Baby photographs

Baby photographs are moments in time that will pass very quickly. A child growing up may not remember time spent as a baby with parents. However, you can catch some wonderful images of parent and child to show the child the importance that the child had to the parents. There are opportunities galore and if you look at this image, imagine how

the child will feel in the future when they can gaze upon an image that shows the child so close to his/her father.

This is a fabulous picture and whether posed or not, it doesn't give the impression of being posed. It looks like a photograph of a moment shared between a father and child. Similarly, a mother being pictured with a baby can also be touching and give the adult child a feeling of how special he/she was to mother. Here's a happy image, showing the love between a mother and child that would have a lot of meaning to a grown up child and would be worthy of a family album.

Family albums

The composition in this photo is great because it blurs the tree, but makes sure that the faces are fully in focus. The ISO was set at 125 for this image and it looks like the light was just right to capture all the detail on the smiling faces. When taking photographs of children the detail is very important. Kids will look for those photographs in their parents' albums because it's a way of validating their importance to their parents when they were kids so children's photographs have more significance than you may have realized.

Another thing that will interest them is how they felt when a new baby arrived. That's another photo opportunity and your family album can be filled with good quality images that make the world of difference to the children who feature in them. The better the quality, the more your family album will reflect the loving care that you put into capturing those moments.

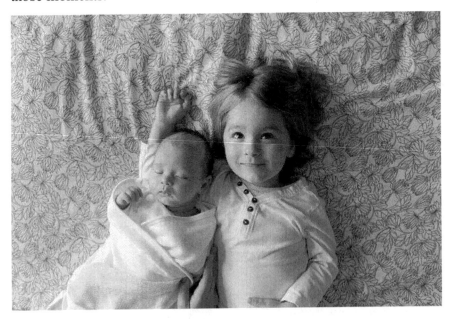

In this image, the clever inclusion of the right colored clothing and background makes the picture stunning. Of course, the elder child

knows that the photo is being taken and that's apparent, but it doesn't really matter because the quality of the image wasn't impaired. This image was taken with an ISO of 5000 and the camera was set to f3.5 with a shutter speed of 1/200s. The high ISO would have contributed to the clarity of the image and the light to capture the image would have been bright, but it was obvious from the image that the photographer did not want the detail spoiled by using flash. By not using flash, colors and patterns are clear and detailed and there was obviously light coming from the left hand side of the image that softens the picture to make it a very memorable image and one that shows the initial bonding between the two children.

The point being made here is that photographs should be pictures of the past. The stages of your children's growth are significant and if you can capture them on camera, these make great memories for them when they are older. I remember going through our family album after our parents died and it was a shame that many of the tattered photographs included people we didn't know and that the quality of the images didn't really give us an insight into what childhood was like. It's not a usual thing to mention personal details, but in this instance, it's very important because your children will treasure those images and if you can present them in such a way that they show the significance of the moment, then you will have achieved a photographic feat that will have made those pictures worthwhile. Of course, families will have portraits done by professionals though these are not the most significant of images to grown up children since they are too composed and usually acquired to place on show in the home. What children look for are the milestones within their lives, and your camera allows you to capture these.

Photographs of siblings

Milestones in the lives of children are important images to capture because you can never relive them. What you need to do is have

your camera ready at all times. Remember the first tooth that grew, or the baby's first steps? These are all things that you can capture in photographic format. Siblings will go through all kinds of experiences together and that picture of the two kids side by side doesn't measure up these days. There are better ways to portray the relationship between the kids and the milestones that they go through together.

Look at the interaction between these two kids, and you will see what is meant by composition. This is vital to your photographs, it also means that you capture a moment in time that means something to those children.

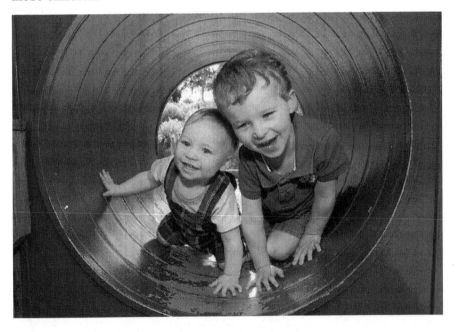

Isn't that better than an image of two kids standing ready for a photo to be taken? It's more spontaneous, it's perfect composition as well and the light and aperture were perfect. The ISO was raised to 400 to allow for the lack of light. Look at the reflective value of the metal and the way that it showcases happy faces.

Taking pictures of your kids will give you a lot of pleasure, but think how much more you can do when you can take great pictures of kids. People will be asking for your help and it's a real pleasure providing pictures for your friends of their kids too!

CHAPTER 21

SPECIAL EVENT PHOTOGRAPHY

One of the reasons that photographers go to great lengths to learn the ropes is that you can't have a reshoot of a special occasion. Once it is gone, it's gone forever. Wedding day can be a very stressful time for photographers, and even if you are not the official photographer on the day, you may have much insight about the guests that the photographer doesn't have. Taking photographs which include these friends can really be nice and it's great to have another take on the wedding other than the official pictures, so do take your camera.

Weddings

One thing that the groom may never see is his bride arriving at the church. Sure, the official photographer may come up with the posed images that professionals usually take, but what about the nervous look on the bride's face as she waits to go down the aisle? You can capture that, or even her look of serenity as she stands in the church doorway ready to meet her groom. You may even want to catch a photograph of the bridal bouquet. It's a pretty special image and will have cost the couple a lot of money.

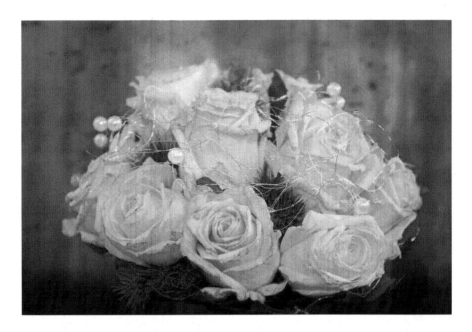

The groom may be pleased to see the images of the bride preparing at her home and these photographs are photos that the photographer will not have taken. If you can have your camera ready and make sure that you use your light meter to get the images perfect, you will be able to share them with the bride and groom once the photos come out. The best thing about digital photography is that you get a second chance. If the picture is not perfect, adjust your camera and take another one. It's not worth losing that golden opportunity.

If you are able to take photographs in the building where the marriage is taking place, be aware that some registrars do not allow flash, but this also gives you a golden opportunity to test out your ability to adjust the exposure so that the picture is perfect.

Imagine if you could get a shot of the bride and groom placing rings on their new partner's finger. That's a very intimate shot and one worth getting.

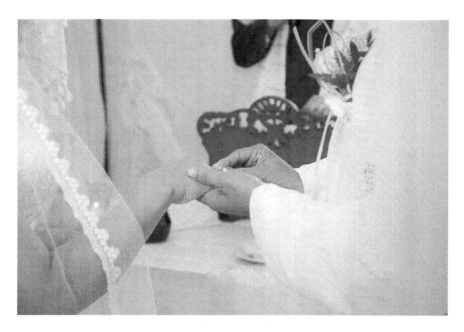

Remember, look for the best angle without being too obtrusive.

The group photographs will always be dealt with by the professionals but you can take candid shots of guests or the cutting of the wedding cake at the reception and your pictures may be even better than the professional ones because you know the personalities that go with each picture.

The prom picture

Everyone has these but how many people take more than a snapshot. The point here is that this is a huge event in your son or daughter's life and if they have the photo they can cherish it forever. At that point in the lives of teens, they are optimistic about the future and the photograph may help them get through the rough times ahead. Young people can forget how wonderful they looked on that special occasion and they need reminding from time to time that they are very attractive. The perfect prom picture will do the trick. Most people take a photo of the

couple and leave it at that. If you Google images that have been taken by proud parents, half the time, the composition is lousy at best and the picture doesn't make a young girl feel like a princess.

Teens are stepping from a world of being a child into being adult and that's a very important step. They will soon know all the hassle that comes with it, but prom night for a girl is possibly the first time that her parents will see her for what she really is – sexy and grown up. Look at the image below. In this image, a simple draping of a sheet in white means that the major impact of the photo is on her. Now that's a prom picture worth having taken because it shows her how beautiful she looked.

An aperture of f8.0 was used for this image, taken with a Canon, and the ISO was set to 100 while the shutter speed used was 1.100s.

You have to admit the picture is pretty special.

Other special events

There are all kinds of milestones that are suitable for wonderful photographs and if you take your time with the images and compose them in a really nice way, these make keepsakes for the kids long after they grow up and have kids of their own. Think of all the events that you can use your camera to celebrate: birthdays, driving test pass, anniversaries, etc. and the scope is unlimited. Even events such as becoming pregnant are important milestones in the evolution of a family that can be photographed and can serve to show the children how proud you were of carrying that child.

In this image, there is an obvious sharing of the moment because the way that the hands are posed, and the fact that husband and wife are

shown equally celebrating the pregnancy, the composition works well. Of course, you can take photographs of this kind of event in your own way. The above image is merely to demonstrate a way to make this something memorable.

Helping a child to tie his tie for the first day at big school can be a really exciting moment. The child is growing up. He is uncertain about what lies ahead and the photo can be very nostalgic indeed without being yet another embarrassing child photograph.

CHAPTER 22

WHY DEPENDING ON SOFTWARE EDITS MAY BE A MISTAKE

One of the problems with modern software is that it allows a photographer to get terribly lazy. With all the manipulations that people can make to digital photographs, some photographers are less concerned about composition, exposure and the quality of their images because they put their trust in their software to correct anything that went wrong.

So what's wrong with this?

The easiest way to explain it is in terms of pixels. You remember all those details the camera salesman gave you about the importance of pixels when buying your camera? Well, he did that for a good reason. The more pixels make up an image, the greater the resolution and that means that you can blow your images up to larger sizes without impacting the quality of the image too much.

When you crop a photograph, what you are doing is chopping off a lot of the pixels from around the edges of the photograph where the cropping occurs. That leaves you with a picture that is grainier because you want it to fit the same size of frame but you are making it fill the page with less pixels thus stretching the pixels from a part of your photo. Thus, the quality of the image will diminish.

Look at the image below because this gives you good detail of what grain is. This happens when you try to make a picture bigger or have taken it with the wrong exposure. The grain that is showing on the image below would spoil the quality of the prints produced. Thus, you do yourself no service cutting a larger photograph down to make it

look more like the original idea that you had when you took the picture. Take time to compose your images because this is going to improve your photographic experience, rather than using software as a crutch. Of course you can use a professional software such as Photoshop to improve your images, but imagine if your images became so good you didn't have to.

Image: Creative commons

The other disadvantage of relying too heavily on your software is that you do not learn how to use the different settings on your camera, compensating for poor results with editing. This is obviously disadvantageous since it stops the learning curve in its path. For example, under or over exposure can be compensated for with software, but what a picture that is under or over exposed says is that your settings on the camera were incorrect. It is far better to take time in understanding all those settings and thus coming up with great images without the need to change what you did wrong.

Red Eye

People who look directly at the flash during the taking of a photograph will show up with red eyes on the eventual photograph when really all that is needed is a slight adjustment in their posture to fix the problem. Many people are disappointed by the "red eye" phenomenon but can fix this without having to use software. Software makes a photographer

lazy about the pose and that's a bad thing. A photographer who is aware of the possibility of red eye can ask the people in the photo to pose slightly differently so that the flash does not hit them in the eye. He can also use an extended flash much like that used by the press to avoid this happening. As we said in the outset of this book, using a flash isn't going to help the quality of your images especially if you don't take them in a studio environment and let's face it, most images are taken in a less formal setting. If you can use a tripod, increase the exposure time and lower the ISO you can get some stunning images.

The quality of images

People often try to compensate for bad quality images using software because they have not set up their camera correctly. Using a large storage memory card, you can adjust your camera to take either mediocre quality images or you can up the specification and take quality images.

Because quality images take up more space on the card, people tend to opt for somewhere in the middle and this is a huge mistake. It would be better to have a couple of free cards and set the camera for optimal performance, rather than using software to compensate for bad quality images, simply because the setting is set in such a way to maximize the number of shots which can be taken, rather than depending upon the quality of the images. That's a huge mistake.

Use the camera to get the very best shots that you can and always opt for quality. If you decide to take the easy road to having masses of mediocre photographs the quality will be less and your images will show it. On a screen they may look great, but as soon as you go over to the print process, it will be noticeable compared with images using the higher setting that adds more pixels to the image and thus fills in any potential grain caused by lack of pixels on lesser quality images.

Learning the ropes from your camera handbook

Read the booklet that came with your camera and learn what it is capable of doing. If you have lost this, you can always download a copy from the Internet as most quality manufacturers allow you to do this. If you need more specific help with a problem that you are experiencing with your camera, why not see what's available on YouTube because there is some amazing information out there which may address a specific problem that you have encountered. Don't be shy of finding out more information. Every time you learn a little bit more about your camera's capabilities, you improve your chances of taking great shots and that's a real plus.

CHAPTER 23

CAPTURING THE BEAUTY OF MOMENTS IN LIFE

Photos, to be fully appreciated, should not look like they are scripted. These could include images of events in your life and the unfolding of your personal story. Church gatherings, barbecues in the garden, school sports events etc., all come under this heading, as they are moments in life that matter to you and your family or other participants in the event. The event may even be the first steps of a child caught on camera. They may be the new born baby in the hospital. Whatever they are, they shouldn't look as if they have been posed for the camera, if you actually want to capture the essence of the moment.

When a photo reveals the story that it is telling, you call these candid photos. Knowledge about candid photos gives you the edge if you want your photography to have more significance. It is perfect for keeping moments that you wish to cherish. Bear in mind that some of these will be photographs of still items, while others will involve the movement of people and this is vital when it comes to choosing your lens and settings on the camera. For more candid shots where the people who will be in the picture are unaware that you are taking their photograph, a telephoto lens or a zoom lens will be ideal. These allow you to get in close without making the subject of the photograph conscious that you are snapping them.

Supposing, for example, that you want to catch Johnny in his first school race. This involves movement and you can still capture wonderful pictures of movement as shown in the chapter with the image of a young girl in the water. The way that you do this is to focus the camera on a fixed spot that is at the approximate distance that the

photo will be snapped. Thus, in the case of taking a picture of Johnny in the race, focus the camera on an area of the racetrack where you have a great view.

As Johnny starts his race, hold the camera with the same setting and focus as you had and follow him until he reaches the point where he is completely in focus. Then snap. Your picture will show the motion but the child will be totally in focus.

There are different types of candid photography but the most prominent of them are *street photography* and *reaction photography.*

Street photography is just as the name implies. You go out for a walk and take the opportunity to take photographs of things that you believe will make a great picture. This could be anything from the orange color of the leaves in autumn to the flowers in the park. They are spontaneous pictures that you want to have in your collection of photographs. Reaction photography happens when you want to frame a response to a certain stimulus. If your friend secretly planned a wedding proposal, you surely want to see and capture the reaction of the bride to be. This could cover many events where surprise reactions are shown and you have your camera ready to capture the moment.

1. Your camera and you - The first tip that you should follow is this-- always take your camera with you, no matter where you go. The fact of the matter is this, life is full of surprises and you do not know when the next big thing can happen. And if nothing huge or worth photographing happens, you haven't lost anything. The plus of always being ready means that unexpected events may just catch your artistic eye that you would have lost had you not had the camera with you. So, go ahead, take your camera with you, always. The kind of things that can happen are skies that amaze you, elements of nature that you may not have noticed before, architecturally interesting houses. In fact, when walking, you could see things that you hadn't noticed before even if walking in an environment you are familiar with. There are

always surprises waiting in store for the observant.

2. No flash rule - Again this reiterates the rule about using natural lighting. Besides, if you want to capture your friends doing something hilarious, the magic of the moment will be gone once they take note of the glaring flash. If you can get away with taking photographs in natural light, this is far better from a quality point of view. If you do need to use flash during hours of darkness try to use an extended flash rather than depending upon the built in flash in your camera as this will cause quality issues.

3. Take as many photographs as you can - If you want to capture events in a simultaneous manner, you might as well activate your camera's multiple shot option. The settings usually have that feature-- the shutter release has to be pressed once and multiple photos will be taken. This is particularly good for action shots. Supposing a lorry ran amuck into the shopping mall. You have an ideal opportunity to grab as many shots as you can and these may be useful to the police or to the newspapers who report on the event. They don't have to be negative events. Sports events are also times when this feature comes in extremely handy. Thus, if you miss the perfect shot with one photograph, you may find that the photos that follow get the perfect image.

4. Activate the long zoom setting - If your subject is far away from you, and you have no capability to get close to it, activate your long zoom option. This feature is also useful when you want to be sneaky; the subjects will not know that they are already in the photo shoot so their reactions become more natural. This is particularly good for spontaneous moments with children. If they know you are taking photographs, children will pose and the pose may spoil the spontaneity of the photograph. When children are unaware that they are being observed, there really can be some magical moments captured on camera using the long zoom setting. On standard point and click cameras, there is usually a rocker switch at the back of the

camera. Familiarize yourself with its position so that you are able to switch from one mode to the next effortlessly and without having to stop to look where the settings are. That one moment taken to look for the settings may be enough to miss the moment.

5. Caught in the act - Is perhaps the best technique there is when taking candid photographs. While your children are so enthused with their activity that they act in a natural way, while your friends are dancing, while family members are telling are smiling about something that has just happened-- those are some of the best activities you will want to capture. You may catch a family member cheating at Scrabble or even find that the concentration between father and son while playing a game of chess can be put to good use by taking a photograph a low level to gain better perspective.

Another key factor to make candid photos is to be invisible-- okay, you cannot really become invisible, but there are known tips that you can perform to be "out of sight" even just for a little time, enough for you to be able to take natural photos. These tips can also be useful for taking wildlife pictures, where you may lose the opportunity if the creature you are trying to photograph becomes aware of your presence.

Be sneaky! Follow these guidelines to become invisible:

1. Use your hips - This is a very practical tip. A photographer often has a certain pose: camera near the face, and slightly crouched down. If your camera will lay on your hip, they will think that you just have the camera, but you have no intention of taking the photo. Well, they might just be wrong. What you can do in an instance such as this is make sure that the automatic button is pressed and focus on about the distance that you need. Another way you can achieve this is if you have a swivel LCD display and can look down into it. These are quite sneaky for taking candid pictures when people are not expecting it.

2. Tone down on your equipment - If you want the sneakiest of photos, you must avoid bulky devices, which will be too obvious.

If you have a digital compact camera, you can use that instead! There are also point and shoot devices which can be quite useful, although the quality of the photo can be compromised. One gadget they may not be expecting you to use is your iPad or phone. These are quickly manipulated into place and you can take an image. It may seem surprising though old folks really are unfamiliar with these new gadgets. I recently took an image of a very old lady on the iPad without her being aware that I had taken the image. When she looked at the photograph, she said that she was sure she knew this lady, but that she didn't know where from! It was a great moment, but it was also a pleasurable moment that we shared and still laugh about.

3. Time it - Shoot only when you subjects are distracted! As much as possible prevent yourself from urging them to become distracted, as they will know right away that you want to take photos. Just be patient, after all, they will NOT wait for you to take photos, so be patient and wait for the ideal opportunity rather than drawing attention to the fact that you have your camera and are ready to take their photographs.

4. **Start taking photos of landscapes** - This is a good tip that will go well with tip number 3. First, start taking photos of still life, food, the landscape, trees, or anything else that does not involve people. You may have it in your mind to shoot a picture of someone nearby. However, the fact that you are busy shooting pictures of other things will put them off the scent. Then move your camera down and snap the shot.

5. **For nature pictures** – These take a lot of patience. You have to wait for nature to pose on its own without letting nature know that you are watching. Animals are very protective of their territories and you are unlikely to get a good shot if you are too close to them. You can use a telephoto lens, but you can also get really close by using a hide. This is a screen that is placed between you and them and which is covered with natural leaves or branches so that the animals are not aware that you are there. In nature reserves, there

may already be hides that you can use to get close to nature, since it is a common thing that photographers want to take pictures of animals in their natural habitats.

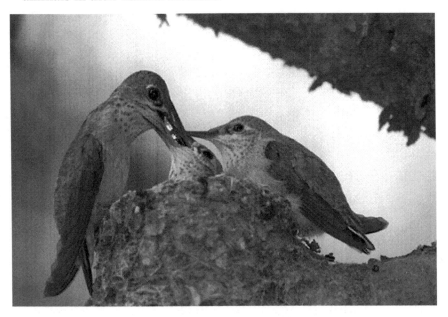

Image: Creative Commons. See how a moment in time is captured using a telephoto lens.

The above image is a very imaginative one and something that is rare for the public to see. For a photographer to get an image such as this, he needs to take time, to know where birds are nesting and to observe their activities.

Usually animals have set feeding times. For example, squirrels may use the same route to get to their feeding grounds every day. If you study the animals that you wish to photograph this gives you the edge. You will be able to set the camera up in advance and simply wait for the opportunity to arise.

The problem with amateur photographers is that they don't usually understand the amount of waiting time professional photographers

need in order to produce the quality pictures that they see every day in magazines. These are produced with quality cameras and the amateur could be excused for thinking that his/ her camera does not have the same capability. However, patience plays a huge part in how well you will be able to take candid photographs of wildlife.

Taking the time to understand the species and its activities will mean that you are much more likely to succeed. There are some marvelous pictures of dragonflies that were taken by a river on a summer afternoon. The photographer had to take hundreds of images before a perfect one was achieved, though by knowing the habitat of the dragonflies, and also knowing that with time, they become accustomed to human presence and even sit on your hand, they were able to get close up images of the dragonflies and even set up images against a dark background which reflected the beauty of the blue/green wings against it beautifully.

Patience is the biggest asset a photographer can have and when it is exercised the results of the images produced are much better and much more surprising.

CHAPTER 24

OTHER REMINDERS WHEN IT COMES TO PHOTOGRAPHY

Considering all the tips above, you should also be reminded of some rules. Remember that photos today are not just for memories; they also serve the purpose of sharing moments with the people close to you, and even with people who feature in those images. You may even be fortunate enough to compete in competitions with the images that you produce or to use these for online projects.

These reminders will help your photos stand out for all the right reasons.

1. Permission matters - Okay, so let us clarify this reminder. In the previous chapter, you were asked to become sneaky, but please still use your judgment. Be sneaky only around people whom you are close with. If you are taking photographs of strangers and want to use them, you need to ask them if this is acceptable.

If you are using the pictures for commercial purposes, the agreement should be put into writing. In fact, a form of consent is something that you should get accustomed to having on you in case you see something that you really do want to take a photograph of which is essentially private. For example, one photographer wanted to take pictures of someone's garden and got so enthusiastic about it that he actually trespassed to do so. The police were called and they were under the impression that he was casing the house for a burglary, when in fact all he wanted was photographs of the roses in the garden that were of a particularly rare species. To save the embarrassment, all he had to do was to ask the owner if he/ she minded if he took photographs. Most

people are so proud of their gardens that they would probably be only too glad to share their joy with others. Politeness should always be in mind when photographing the property of others.

When taking photographs of children, bear in mind that parents may be fearful of where these photographs will be used. With so much danger these days with online photographs, don't assume you can post a photograph of a stranger's child onto your Facebook and get away with it without asking the parents first. You may be endangering that child. While you may have found the child particularly appealing from a photographic stance, pedophiles may find the child equally endearing. Always ask and always inform parents of where you intend to use the photographs.

Joke time

When you are in an actual photo shoot and you want the emotions to be light and happy, you have to do your part by making an effort to make people laugh. Punch a joke from time to time and press the shutter release when their laughs are at their most candid! You may not have noticed this, but look into the window of any professional photography shop and you will see spontaneous pictures of bride and groom or any of the bridesmaids at the event who have been photographed looking wonderfully calm and happy. Professional photographers do know how to make people feel at ease. If you want to take photographs that are equally as professional, remember to hone your communication skills so that you can take photographs at the opportune moment and get the best pictures possible. The image of the child shown in the photo below is a stock item used on a photo website where the photographer would have had to give permission for the use of the image. The reason it is so relevant is that little smile on her face. If you think that this happened by accident, think again. While the child may have looked perfectly delightful caught in a sunbeam, look how much her smile adds to the image. A small prompt from a photographer can do this, and the results can be stunning.

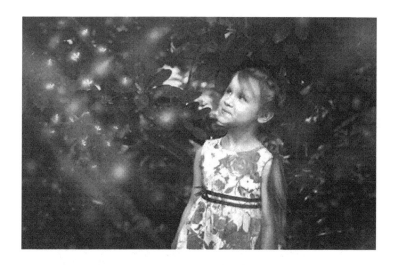

Image: Public Domain

Learn, learn, and learn

The first mistake a person makes when wanting to be involved with photography is investing so much on equipment and neglecting the learning process. Research on the Internet if you have questions. Be inquisitive and subscribe to photo newsletters, if there is an available photography community in your local area, join it! The best place that you can get advice on the use of your camera is in the leaflet that comes with it explaining all of the features. Unfortunately, in many cases, people get so involved with using their camera that this gets thrown away right at the start of their photographic experience. However, that isn't the end of the story. Most quality camera manufacturers have websites from which the handbook can be downloaded.

They also have backup with technical staff and if you are concerned about any aspects of your use of the camera, you can always ask them. Kodak were particularly good with giving advice about the use of their digital cameras and many others will be able to help you to gain the most from their products.

These companies want your custom and a good customer experience usually means that when you upgrade your camera, you are likely to stick with a company that you have learned to trust.

Avoid chimping

Be honest, while taking pictures, what you do is take one photo and look at the photo. That's what you call chimping. The problem with chimping is that you lose time inspecting the photos that you have already taken instead of looking for more prospective moments. People who do this are usually timid about their use of their camera and it's a better idea to read up on the features and try them out in your own time so that you get more familiar with the features and don't have to keep stopping the photographic experience through your own insecurity.

By stopping, you may be missing moments that are better than the moments you just captured on the camera. It doesn't matter if you have occasionally taken shots that are not good.

It's not a failure. It's a normal occurrence. If you were to talk to a professional photographer, you would learn that even they make mistakes. Stop holding back your own experience by being so unsure. Take extra shots instead and when it comes to dumping the bad shots, you will no doubt have good ones to replace them. When you see an album of photographs after a wedding, you are not seeing every image that was taken. You are seeing what the photographer saw as the best of all the photographs they had to choose from. He will, of course, have scrapped some photographs. No one wants to see the best man yawning. No one wants to see the moment when the bridesmaids made a mistake. These get deleted. Thus, no one really minds that you take some shots that are not that good. It's part of the photographic experience.

Framing your Image

Framing is when you use natural frames to emphasize the subject. For example, the scene is framed by a window, look at the window and

see if it will also be a good element to include in the picture. Tunnels, doors and even lighting can also be used as natural frames. If you are walking down a road and notice an archway to a garden, this makes a delightful frame to a picture.

Don't forget to ask permission if this belongs to a private individual, but the image you wanted of the river across the road from that arch, may actually be wonderful framed by the garden arch. Taken from inside that garden, the shot could be perfect. Similarly, in architecturally interesting places, arches may frame the picture of the medieval buildings beyond it.

Consider the frame as creating a vignette. The old art of vignettes was often used in photography and an archway may cause a dark area around the edges of an image, but what startles the eye is the bright garden or shrubbery that greets it at the end of the darkness of the archway or tunnel. There are some amazing pictures of nature that use trees at the edges that in effect frame the image within the center of the photograph. Just as you compose photographs as explained in previous chapters, framing is a technique that helps you to get great shots and very unusual photographs indeed which show your originality as an artist and photographer.

Get involved with your subjects

Getting involved in taking photos means that you will not fail to see the beauty of what you are trying to capture. The problem with most photographers is this. They want to take the best pictures and give precedence to quantity rather than quality. It's necessary to have a good eye for detail. The cobweb lurking in the garden may give you the ideal photo shoot. The dandelion that you see in the middle of the lawn may also give you a photo opportunity. Don't ignore the possibilities and take time to appreciate what's in front of you, before, during, and after capturing the picture. You may be able to use different angles and different lens settings that all help with your experience of the camera

and sometimes the results that you get are so good that they enthuse you even further to be more observant.

Mark your images

And lastly, to make sure that no one will take credit of your photos, mark them with your name if you are going to use these online. Be aware that websites such as Flicker and photograph storage websites may have user agreements that you may not have read properly allowing people to use your images without you even knowing it. If you watermark your images and make sure that your settings on such websites are set to private, you may be able to avoid this.

Be more aware of your photographs

The object here is not that you copy other people's ideas but that you learn what works as a photograph. If you look at photographic magazines, you usually get a good cross section of images and can see what others did that perhaps you have never tried.

Although your image will be individual, you may find that techniques used for taking photographs are something you never thought of before. This widens your potential as a photographer because these images will help you to see the importance of composition, or lighting or even the way that the photographer used the elements in the photograph to present it at its very best. Look and learn because all of this exposure to images helps you to gain perspective and to use it when your camera is posed ready to take the next shot. It's always good to keep up to date with the kind of effects that can be achieved because you might just win a competition with your attempts at new techniques.

It's worthwhile visiting an exhibition from time to time and looking what works for others. Even glancing through the pages of a photographic magazine can give you inspiration. All of the images that your eyes process over the course of the day are potential for putting a photograph together. Be aware of your surroundings because that way,

you will find that you won't miss so many photo opportunities and will be glad that you had your camera with you to capture moments as they happened.

If you are aware of your own shortcomings, this helps enormously because admitting that you are getting something wrong is the first step toward getting it right. All you have to do is work harder on your weak points and improve upon them. It's okay taking the same kind of photographs that you know you are good at, but learning new techniques also helps because then you become good at other types of images and can produce quality whenever you want to. The freedom of expression that a photographer is given is really something that you need to explore because it will widen your horizons and make you try harder. The best photographers in the world are still learning new tricks so don't think yourself slow just because you don't know everything. No one ever does. Just do what you can to continue the learning experience.

CHAPTER 25

WHAT TO REMEMBER WHEN PRINTING

After the photos have been taken, the most common practice is for people to upload them and share them with friends using their social media accounts or by sending them via email. It is true that this method is very convenient, what with not needing to print the photos before you can show them to the world. It's also practical, because there is no need to invest in photo papers and ink.

The only dilemma with not printing the photos is the hassle of retrieving them from your computer each time that you want to see them. Often times they will hit your news feed like storm but only for a day, after that, your photos are good as buried. You may have them in files on your computer, but what happens the day that your computer packs up and is no longer usable?

When they are printed, you will be able to pull out your photo album each time you want to enjoy your photographs just like you did in old fashioned times. These are more permanent and you have easy access to them. It's much handier than having to turn on the computer at a moment's notice when you want to show someone a particular image. If your pictures are only stored online, there will be no need to look for an Internet connection-- the memories are there in front of you, tangible and solid.

You have to be honest-- photos are best appreciated when printed. But of course, there need to be some reminders to help you make the most of your printing and to avoid unnecessary waste. In this section, you will learn the techniques to make your photos more amazing when they are printed.

1. Choose the best photographs - Although you will probably get a lot of amazing pictures, not all of them are worth printing. Choose the best photos you would like to display in your living room or in your office, framed or inside an album. You will have loads that are simply not good enough because you were encouraged to take a lot of shots just so that you have more chance of success. Consequently, some of these will be inferior.

2. Correct, but don't overdo it - One common mistake people make when editing photos is that they do so much correcting that the real beauty is taken away. Just remove things that will be distracting (by cropping out), but as much as possible, you have to keep the photo original. This is necessary because of the pixels as previously explained. You actually detract from the quality of the imaging by cropping and that's not a good practice.

One good tip on this one is making a copy of the photo before editing it. This is a good safety measure in case you wound up with a result that is disappointing.

3. Sizing your images - Make sure that you are printing your photos at the appropriate sizes. Pictures that are too big may become pixelated, and too small may mean that the photo will lose impact. There are also services available on the Internet where in you can change the format of your photos into vector format. This format is very appealing because you can resize the photo all you want and it won't get pixelated. You can even turn them into instant wallpapers and the quality will still be intact!

4. Paper and ink - As much as possible, invest on these two and make sure that the printer you choose is one which allows you to use small format paper as well as the regular size. Your photos should be made to last so the quality of ink and paper are very important. The technique here is to see which paper matches your ink, or vice versa. Try different surfaces. You can buy papers that are glossy or you can

print on semi mat that is very attractive and stops the glare if you are thinking of framing the images.

These techniques, of course, are just basic. Once you have involved yourself in photography, you will learn a whole lot more-- most of the processes are complicated, involving technical details concerning your printer, the calibration of the print colors, etc., but, for now, it is enough to know that your photos can be manipulated so they will turn out even more amazing.

Naturally, well taken photos combined with minimal editing will make all your efforts worth it once you see the results. Look at the image below. It shows the kind of contrasts that are really suited to printing. The blacks are true, as are the lighter colors and thus the print will be superb.

CHAPTER 26

COMMON MISTAKES AND HOW TO PUT THEM RIGHT

No photographic guide would be complete without a trouble-shooting section. In this section, we deal with common problems that people may experience when they are taking photographs and try to give you answers on how to fix those problems on the spot so that the next image that you take will not be as disappointing as the one currently showing on your viewfinder. Everyone encounters problems so don't be at all concerned about them. These problems should be thought of as learning curves because if you use your mistakes to learn from, you will improve your technique and be able to take wonderful images without too much trouble at all. If you ignore the problems, you will continue to make them and use your software to fix them and that's not what real photography is all about. Your camera has the means to take focused images in the correct light and with the correct composition, but adjusting the camera and trying out various angles before taking the shot is the task that people today who are rushing to take images forget.

Be ready to do your homework, because these are common problems and you will encounter them from time to time.

Over exposure

What this means is that the image is too light and that too much light was let into the camera. If you can try and think of a triangle of the three items that this could be caused by, it makes it much easier to understand. ISO = Noise on Image, Aperture gives you depth of field and shutter speed is more for motion and can create blur.

You have three options. You can either reduce your ISO setting, move your f stop to a higher number or you can simply adjust the speed of the shutter.

If all of that seems too complex at first, it isn't once you get accustomed to changing your settings. The other alternative is that you can use a filter to cut down the amount of light getting into the camera or to mask it off a little. This is super quick solution if your picture really isn't too bad but just needs a little bit of adjustment. You generally only use filters for this purpose during daylight hours.

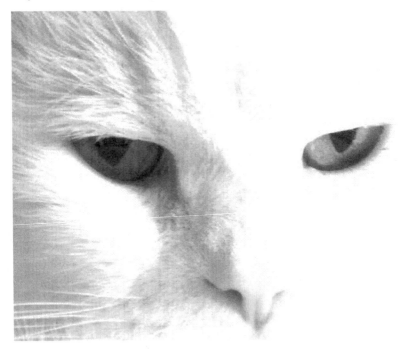

This image is unfortunately overexposed. You can't see the color definition of the eyes very well and this is a special breed of cat that has eyes of two colors, green and blue. You can't see the fur on the cat because there's too much light. The exposure of the image is vital to how the picture looks. A cat such as this breed offers the photographer a wonderful opportunity and in this case, it was missed. Now look

at an image where the photographer actually got the settings and composition right.

The detail of the eye colors is perfect. You can also see the texture of the fur and that counts too because it adds so much to the image that didn't show on the over exposed image.

Under Exposed Images

This means that your image is too dark. This sometimes happens when you take pictures at night or when it's dusk and you may need to compensate for it to let more light into the camera. However, you run the risk of showing shake on your images. Do the opposite to what you were instructed to do for over exposed images and up the ISO, move your f stop to a lower number and use a tripod and slow down your shutter speed. This is particularly relevant for taking images such as pictures of fireworks in a night sky. The moon coming up or the sun

going down or stars in a dark sky, etc.

So what does an under-exposed image look like? An under exposed image will look darker than you intended it to be. It won't show detail. There will be no real contrasts and it won't look stunning because of this lack of detail. The extra light getting into the camera helps the camera to pick up these details which would otherwise be lost and they are vital to night images or images which are taken in dark places without the use of flash.

Look at the detail on this image of a lamp. Although it might have looked nicer taken portrait style rather than landscape style what it does demonstrate is perfect exposure for a night picture. You can distinguish the edges of the lamp quite easily and that's very important as a guide as to whether an image is under exposed.

Camera shake

Although you may consider yourself to have very steady hands, if there is any blurring of the image that you take, then the chances are that you have experienced camera shake. For the whole time that the shutter is open, you need that camera completely steady. If you can invest in a good tripod, do so, as your pictures will improve.

Movement of subject causing blur

This can happen when you are taking photographs of something that is moving. The way to counter that is to follow the movement. For example, if you are photographing a motor race, you need to get your settings on the camera correct and then follow the car as it moves before pressing the shutter. You will notice that professional photographers usually have their camera on a tripod that swivels so that they can follow the action.

If the subject moving is unpredictable, then you need a faster shutter speed and a lower ISO. That compensates a little for the movement, but again if you can follow your subject with the camera, you are much more likely to get these to come out clearer. Also use a telephoto lens. Many cameras these days have a stabilizing compensation built into the camera and this helps when you are taking pictures of animals which are moving, such as birds in the garden or squirrels as it allows you to take the image more discreetly and perhaps avoid the creature moving in the first place.

Distance between camera and subject

Have you ever been bored to death with someone showing you their holiday snaps? Every single one seems to be of someone who is too distant to really focus on. The problem here is that holiday snaps are often taken too far away from the subject. You can take very interesting shots and include someone in them, but why stand them half a mile away?

A friend had a particularly bad habit of having her image taken in front of monuments in the same pose every time and the problem is that the photographs were very dull and even though the exposure was correct, they hide the subject because of distance and you don't see the monument because they are standing in front of it. It's important to remember that a better image could be taken if a little thought was given to the composition and the distance between the camera and the subject was lessened. You can either do this with a telephoto lens or you can stand closer to the subject when taking the image. Perhaps standing to one side of the monument would also allow the monument to be seen.

Look how atmospheric this image is. The reason it was taken composed in this way was to show the visitor to that landscape, but to show off the landscape as well. This image has much more impact than a straight image of someone standing in front of a hill and usually when straight images are taken, the camera focuses on the person and misses half the landscape!

It's impressive and interesting and that's what holiday images should be about. If you produce stunning images, people who are not even

interested in your holiday will be interested in looking at them because they are pleasing to the eye.

Lack of composition

This really cannot be emphasized enough. Composition is what photography is all about. Stand with your camera and look at what it is that you want to take a shot of. Look from different angles. Look from different heights. Look in your viewfinder to compose the image so that you don't miss off important detail. So many photographers make the mistake of not composing their images. Look at these as examples where composition might have saved the day. Each has been chosen because no actual composition was thought about at the time of taking the photographs and as a result, the images that were produced were not good enough to be classed as composed photographs. The first image shows lack of composition. The cat has the most exquisite markings and a photo of it sitting or even a photo of its face would have been much more composed and great to look at.

What the photographer ended up with is an image where the paws are even cut off from the photo and this is typical of not really looking at

an LCD screen and composing an image.

In this image you can see what the photographer wanted to show. The cat sitting on the post is quite a good subject, but again the opportunity was missed for detail. The F stop was incorrectly set as the image is over exposed but the composition could have been really stunning with the use of a telephoto lens and concentration on the subject matter rather than all the unnecessary background.

Yet again, it looks like the photographers forget to double check the LCD screen. It had the potential to be a wonderful shot, but instead of

showing all of the facial features has cut off the forehead and ears of the cat.

From these general mistakes you can see that composition is everything. Anyone can take a snapshot but it takes a photographer to take an image that is composed. Try to remember with all of the learning that you are doing that this is vital. Look at the image below which is perfectly balanced and you will see exactly how this makes such a difference.

Image out of focus

There is nothing more irritating than getting home and finding that

your photograph is completely out of focus. This may have happened because you rushed the shot, because of movement or because you didn't see properly using the LCD screen and thought that the image was in perfect focus. If you find that this is happening on a regular basis, perhaps you need to think of getting a camera with a clearer LCD screen, or one which allows you the freedom of either looking through a viewfinder or looking at a screen which is clearer.

Photos that are too busy

Unfortunately, sometimes people take images that are too busy. The background has so much happening that you hardly notice the merits of the picture. Busy pictures can be good if they are intentional but often they are not. If you try to jam too much color and too much busy activity into an image, you can forget about the importance of the overall look of an image. Let's show you two examples. One is busy on purpose and is very aesthetically pleasing while the other is just busy and does nothing to enhance the look of the image.

This image doesn't say much. It's a crowd of people and even as a crowd, it doesn't make any kind of statement. It's not a particularly

busy crowd, there's no atmosphere and there is absolutely no ambiance.

Now look at this image and you will instantly see that the busy nature of the picture was used as part of the composition and it works.

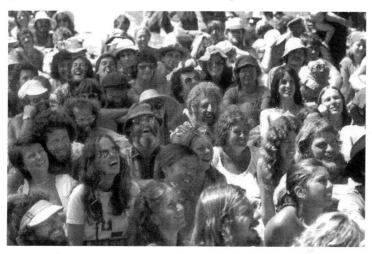

The obvious purpose of this image was to show people who were at a pop concert and to show their happy, smiling faces. The exposure is not perfect, but the image was shown as an example of how crowds can work when composed and purposeful.

Photography is a recording of an event but it's more than that. It shows your skill and your ability to compose a work of art. When you think of what a photograph is, it's an image on paper and that's what artwork is as well. Thought of in this sense, you really can go to town on your detail and get wonderful results which your friends will never get bored with seeing, on the merit of the picture itself and that's vital.

This chapter has dealt with some of the things that can go wrong when you take a photograph. It could never deal with all of them because everyone's camera is different and everyone's idea of the perfect photo will differ too. However, certain standards should be adhered to. Your photo should be composed. It should be taken with the camera on all of the right settings and it should be in focus.

CONCLUSION

Congratulations on finishing this book! Before we end this lucrative journey of indulging in the art of photography, let us first have a recap of what we have experienced together while you were reading this book:

By now, you are more confident in holding your camera, you know its parts, and you know its functions. But don't forget to get back to your manual from time to time. If you have lost this, you can download another copy from the manufacturer's website and it's worth doing because many of the features that you haven't yet used will be fully explained so that you can practice using them and gain more experience as a photographer.

You know what composition is, why it is important, and what the twelve rules of composition are that can make your photo composition more appealing. Use these rules and also be aware of photographs that you see which appeal because you can learn from expert photographers the kind of settings that work well.

You will be able to take photos of landscapes and nature with conviction, using the natural light and the elements of the picture composed in such a way as to maximize the quality of your images.

You have also learned how to take pictures which will be used as family portraits and the way that you can improve your portraiture. The composition and the chosen moment can make the world of difference as was shown in the images in this section of the book. These can be formal or can be spontaneous moments captured on film, but will enthuse you into using close up lenses and also telephoto lenses to capture the portrait in the most natural way.

The art of candid photography was presented to you, and you even know some of the simplest rules that can make you seem invisible to

the subject! We also explained why it is important to seek permissions as these are vital when photographing other people's property or their family members.

Other tips and reminders to help you take photos easily are given throughout the book so that you can maximize your photographic experience. This is just the start, so start taking your camera everywhere with you and hone your skills! Be patient, and be creative-- you will surely have the photos that will impress your friends and also impress you, because you took the time to learn a craft that combines art and the use of your camera in such a way as to present superb images.

You are encouraged to go through the book again at your leisure and to try the techniques that have been suggested. No one learns everything in one read, and it takes time because some of the techniques described may only be necessary for the odd photograph while others will be used on a regular basis. Photography is a wonderful hobby and one that can help you to capture moments in time and remember them as clearly as the day upon which these events unfolded. Your album will tell a story all of its own, but the biggest story will be your learning process, as the pictures get better and better.

Professional photographers take time to hone those skills. Don't expect that they will happen overnight. If you read your camera instructions and start to use all of the features available to you, together with the details in this book, you will be amazed at how quickly you are able to adapt your use of the camera to your style of artistry and produce images that are very pleasing indeed.

BONUS VIDEO: HOW TO TAKE BETTER PICTURES WITH YOUR IPHONE

Video: https://www.youtube.com/watch?v=X1-Bjr-rOw4

Checkout My Other Books

http://www.amazon.com/Photography-Secrets-Beautiful-Pictures-Tutorials-ebook/dp/B00TZAYGG0/ref=sr_1_2?s=digital-text&ie=UTF8&qid=1426343820&sr=1-2